Motionless Journey From a Hermitage in the Himalayas

Motionless Journey From a Hermitage in the Himalayas

Matthieu Ricard

with 71 illustrations, 70 in color

 Thames & Hudson

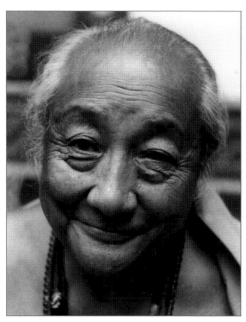

Dedicated to Dilgo Khyentse Rinpoche,
spiritual king of the monks

PREFACE

This collection of photographs is an account of a motionless journey, the fruit of something that most photographers (including myself) rarely have the chance, the time, or even the inclination to do: to sit still for a whole year, waiting for the right light.

Nor, indeed, was that my goal. I did not go into retreat to take photographs. Nevertheless, as I contemplated that sublime landscape from the early hours of the morning, well before dawn, until after nightfall, every now and then an extraordinary light would illuminate the vision evolving continually before my enchanted eyes. The scenes in this book, all taken from the terrace of my hermitage or within a few dozen yards from it, are the fruit of that long 'wait without waiting', and of the joy of witnessing the harmony of nature blending closely with the delight of meditation.

Pema Ösel Ling Retreat ('The Place of Lotus Light'), Nepal, 1 January 2007

INTRODUCTION

From the terrace of my retreat hut, I can look out over the almost perfect circle of the horizon. Dominating the spread of the foothills, the majestic chain of the Himalayas stretches over 200 miles. To the east are the great massifs of Everest, to the north those of Gaurishankar and Langthang, and to the north-west, far away, the Annapurnas. Below, in the west, opens a lush green valley, with hamlets scattered among the terraced rice-fields; and in the south-west is a sacred hill, topped by a monastery which emerges at dawn from the sleepy mists as they are gradually dispersed by the first stirrings of the new day's breeze. The immensity and ever-changing beauty of this sublime scenery permeate my whole being like an elixir.

The silence is so total that I can hear the voices of farmers more than a mile away, as well as the muffled pattering of an approaching front of rain, slowly gathering intensity as it draws near and finally arrives overhead. In the early hours, even without going outside my hut, I know from their calls that a company of long-tailed blue magpies is visiting the forest below. A talkative crow lands on the terrace and runs through his repertoire of raucous cawing, surprisingly diverse and noisy, and interspersed with replies from another crow in the distance. High in the sky above, a pair of golden eagles call to each other with their high-pitched cries. Recently there was a much rarer event – a tiger passed by at dusk, through a field not a hundred yards from my hermitage. At night, when the cicadas fall silent, the only sound is the murmuring of the blood flow in my ears.

It is not hard to understand how conditions like these can help meditation to blossom, nurturing the observation of thoughts as they arise from nowhere and then dissolve, fading away like the chime of a bell. Awareness of the present moment reigns over the flow of time. A retreat is a haven of peace, where a student can grow accustomed to spiritual practice in utter tranquillity.

The hermit tradition has always existed within most of the great religions. For several months or years, sometimes for life, hermits distance themselves from ordinary activities, from family life and from contact with society. What are their goals? Apart from the spiritual sustenance they gain for themselves, how can they contribute to the good of human society? These questions are best answered by considering the hermit's motivation. The initial trigger is generally a feeling of weariness and dissatisfaction with the ordinary preoccupations of daily life – profit and loss, pleasure and displeasure, praise and criticism. As a hermit, what you renounce is not so much the good things in life as the causes of suffering buried in your own mind: aggression, confusion, greed, arrogance and jealousy.

When you realize that all the different things you have done in your life have just followed one after another, like waves on the ocean, and will continue to follow this pattern, without bringing any lasting sense of fulfilment, without giving your existence any real meaning, it is understandable that you might want to stand back, take stock and try to identify the mechanism that gives rise to happiness or suffering. As the Dalai Lama pointed out, 'If you look at life in an urban community, it seems as if every aspect of a person's life has to be so precise, designed like a screw that has to fit exactly in the hole. In some sense, you have no control over your own life. In order to survive, you have to follow this pattern and the pace that is set for you.'*

A hermit is by no means unconcerned about humanity. Rather, he recognizes that in his current state he is incapable of securing even his own happiness, let alone that of others. His underlying motivation is therefore to work on himself so as to be better able to work on the world.

To attain his goal, he must devote enough time to developing, within himself, the inner strength and freedom that he will need in order to face the ups and downs of existence with confidence, wisdom and serenity, and contributing in an enlightened way to the good of others.

A hermit therefore begins by understanding that true happiness does not fundamentally depend on changing external conditions, but rather on changing his own mind and the way it translates the circumstances of existence into happiness or frustration. He sees that as long as he is still not rid of hatred, obsession, pride, jealousy and the other mental poisons, it is as hopeless to expect happiness as it would be to hold his hand in a fire and hope not to be burnt.

Despite appearances to the contrary, the motivation of a Buddhist hermit is based on altruistic love and compassion. His goal is clear – to draw closer to enlightenment so as to become capable of dealing with the world's sufferings. A wounded animal will hide in the forest for a time to heal its wounds, and can then return to roaming the hills and valleys freely. A hermit withdraws from the world for a while until he is healed of the underlying causes of suffering.

He may be less visible than a master who teaches and lives in a monastery, and is accessible to everyone, but the hermit embodies the very heart of the Buddhist path. His presence is felt by all who live in the locality as a blessing and a reminder of what is most essential. In both Tibet and Bhutan, local villagers and nomads also see it as a privilege to take care of a hermit's needs by offering provisions for the coming month or year, which they give him if he comes down into the valley, or leave at the entrance of his retreat hut or cave.

A hermit's day is a full one, and is not spent aimlessly. For most retreatants, the day begins between three and four o'clock in the morning, and ends after ten o'clock at night.

The Buddhist tradition prescribes a wide range of spiritual exercises of great richness – complex visualizations used to transform our perceptions of the world and of people, formless meditations on the nature of the mind, investigation into the impermanent and illusory nature of things and, above all, the cultivation of altruistic love and compassion. When such exercises are repeatedly put into practice for many hours every day, they go far beyond the confines of intellectual reflection to become powerful transformative tools.

The techniques used derive from a 'contemplative science' which is thousands of years old, elaborated by innumerable meditators who practised them for their whole lives. Anyone without some preliminary experience of the contemplative life may find it hard to accept the validity of knowledge obtained through these methods, which are so unfamiliar to most of us. But every branch of science has its instruments. Just as you cannot see the craters on the moon without a telescope, so too without contemplative practice you cannot see the nature of the mind, masked as it is behind the veil of wandering thoughts.

A hermit meditates constantly on the fact that death is a certainty, but its timing is unpredictable. Who knows, between death and tomorrow, which will come first? As he lights his fire each morning, the hermit wonders if he will still be alive the next day to light another. When he breathes out, he feels lucky to be able to breathe in again. Aware of the impermanence of everything, he practises assiduously.

Time passed in this way does not get diluted in confused distraction, or drowned in a flood of disturbing emotions. Every instant is worth its weight in gold, and brings the practitioner closer to the ultimate nature of things. The freshness of the present moment nourishes the meditator's heart with beneficial qualities.

According to Buddhism, all of us living beings contain within ourselves the potential for perfection, just as every sesame seed is impregnated with oil. But we are often unaware of it – like a beggar who lives in poverty but is richer than he thinks, since unbeknown to him there is treasure buried beneath his shack. Discovering this wealth that we already possess allows us to live a life full of meaning. It would be a pity to underestimate the mind's ability to be transformed. All of us have the possibility of dispelling the veils of ignorance, ridding ourselves of the mental poisons that cause unhappiness, finding inner peace and working for the good of others.

Authentic happiness, *sukha*, is a state of lasting fulfilment which is revealed once we are free from mental blindness and disturbing emotions. It is also the wisdom that allows the world to be perceived as it is, without any obscuration or distortion. Finally, it is the joy of travelling towards inner freedom and the loving kindness that radiates towards others.

Personally, I had the immense good fortune to meet my spiritual teacher, Kangyur Rinpoche, in 1967, near Darjeeling in India; and, following his death in 1975, to have spent some time in retreat in a small wooden hermitage built on stilts in the forest above his monastery. Then, from 1981, I had the privilege of living for thirteen years with another great Tibetan master, Dilgo Khyentse Rinpoche, and receiving teachings from him. Since 1991 when he, in turn, left this world, I have often stayed in a little retreat hut in the hills of Nepal, several hours from Kathmandu, at the retreat centre established by Shechen Monastery where I live most of the time. These occasions have incontestably been among the most fruitful of my life.

It is particularly moving to be in retreat in a place where great practitioners of the past have lived and meditated. Such places are powerful sources of inspiration, and to meditate in them for a month is said to generate more progress than a year of retreat anywhere else. There are several reasons for this. First of all, to evoke the lives of these great sages and impregnate oneself with them in the very place where they lived brings a special sharpness and clarity to one's meditation. The sacred place is also a reminder of the unshakeable determination those sages showed in following the path to enlightenment, and of the qualities they developed. The inspiration of the place remains as an invisible presence suffusing every moment, both in periods of meditation and the intervals in between, spent resting, eating a meal or doing other simple activities.

Recently, as I was about to start a retreat for several months in my hermitage, I asked His Holiness the Dalai Lama for some advice. His reply was, 'In the beginning practise compassion, in the middle practise compassion, and at the end practise compassion.'

By compassion, he meant the union of altruistic love with compassion: the former is the deep wish that all living beings may find happiness and the causes of happiness; the latter, the wish that they may all be freed from suffering and the causes of suffering. These two wishes give rise to another – to be able to attain the wisdom of enlightenment in order to better help living beings and to work for their good by whatever means possible. In Buddhist terminology, this is the *bodhicitta*, the 'altruistic wish to attain enlightenment'. As a Buddhist text says, 'Something not carried out for the benefit of beings does not deserve to be undertaken at all.'

* The Dalai Lama, *The Good Heart: A Buddhist Perspective on the Teachings of Jesus*, Boston (MA): Wisdom Publications, c. 1996, p.126

༄༅། །བྱང་ཆུབ་སེམས་མཆོག་རིན་པོ་ཆེ། །མ་སྐྱེས་པ་རྣམས་སྐྱེ་གྱུར་ཅིག །སྐྱེས་པ་ཉམས་པ་མེད་པ་ཡང་། །གོང་ནས་གོང་དུ་འཕེལ་བར་ཤོག །

May Bodhicitta, precious and sublime,

Arise where it has not yet come to be;

And where it has arisen may it never fail,

But grow and flourish always more and more.

Buddhist prayer

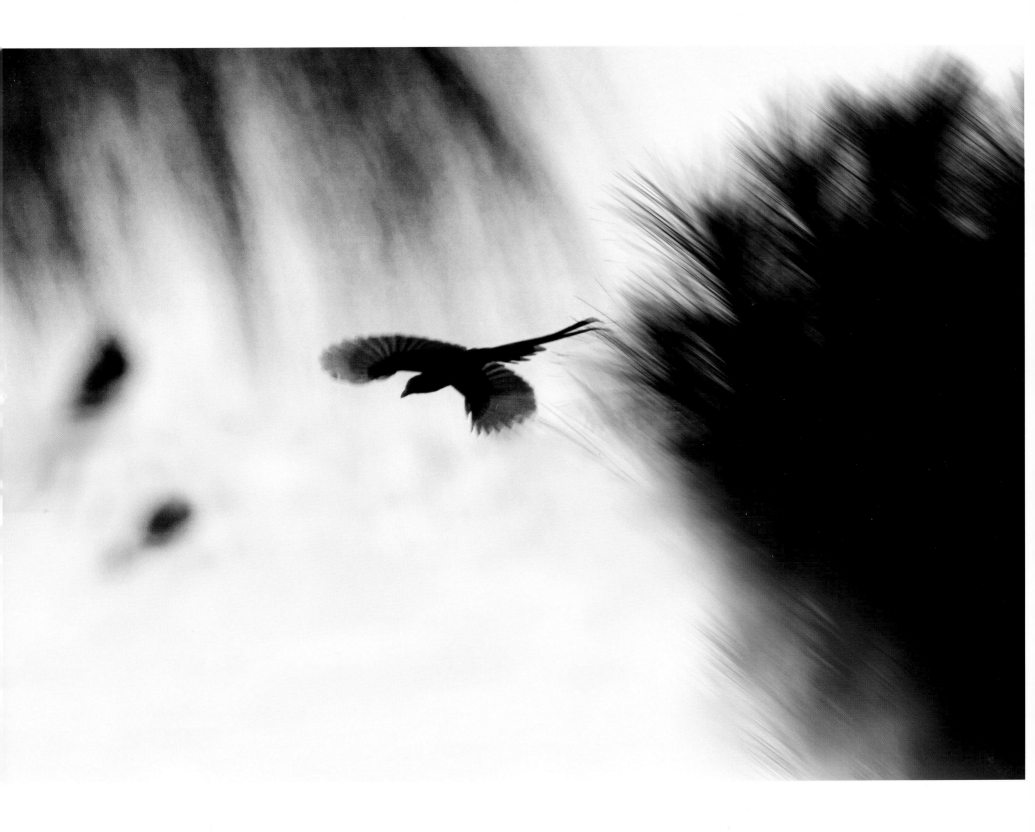

The question is not to know what is the meaning of life, but what meaning I can give to my life.

14th Dalai Lama

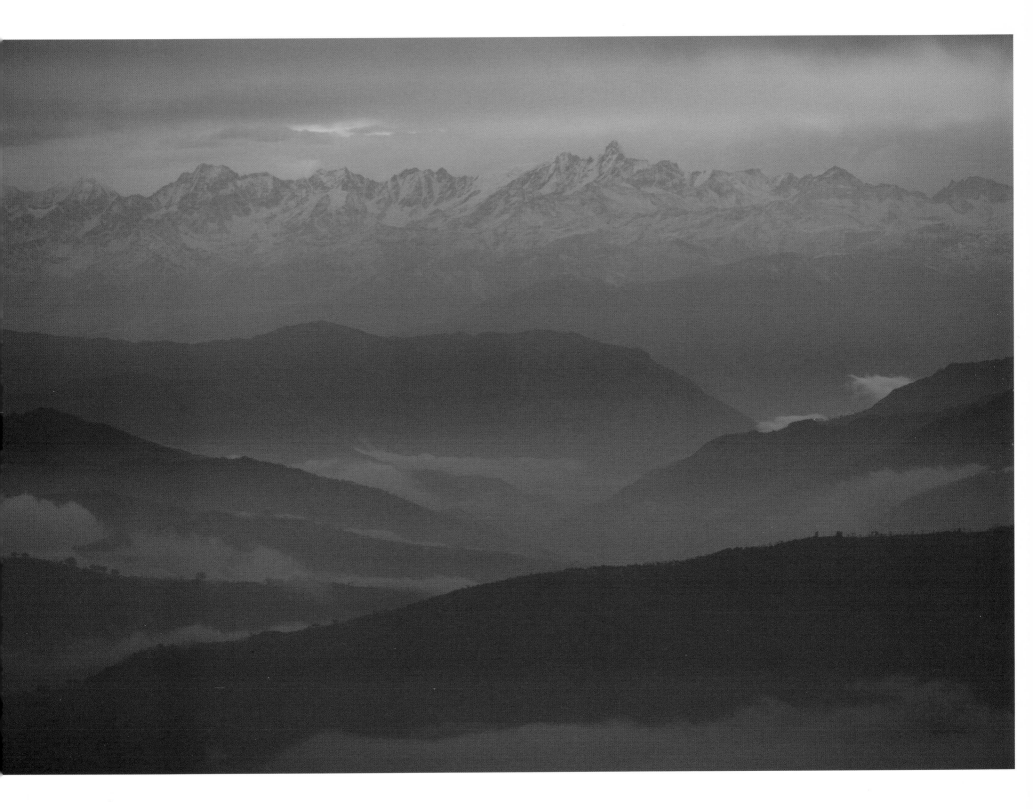

We must be the change we wish to see in the world.

Gandhi

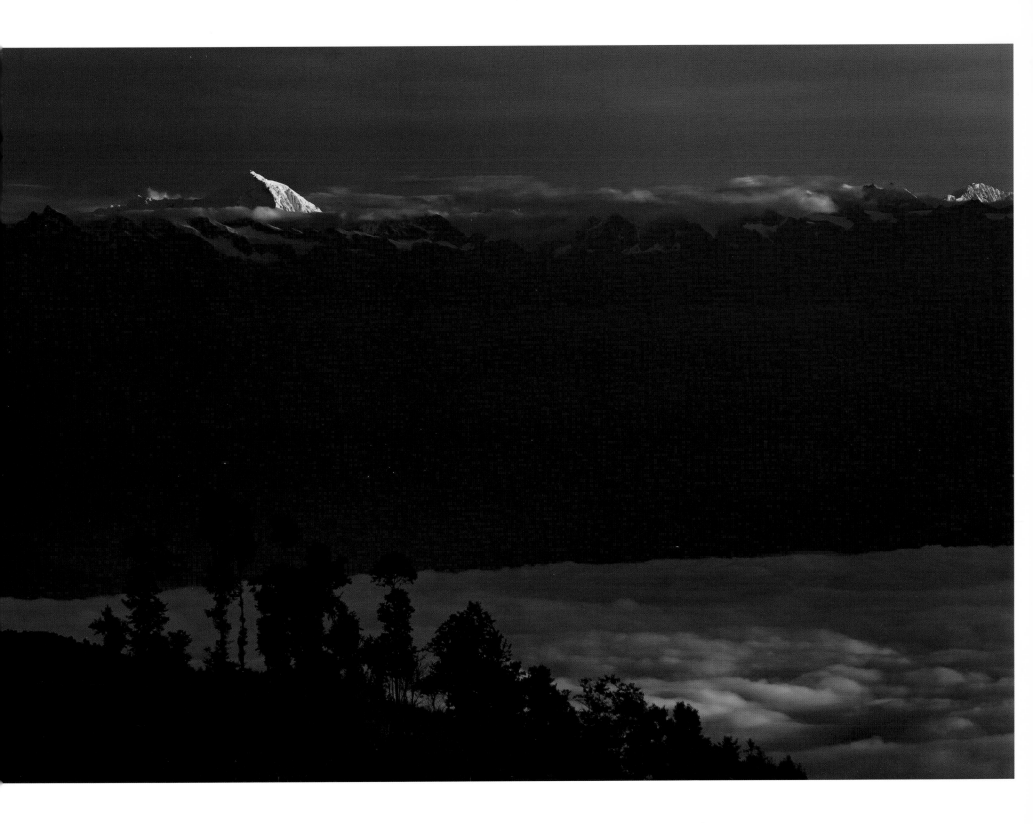

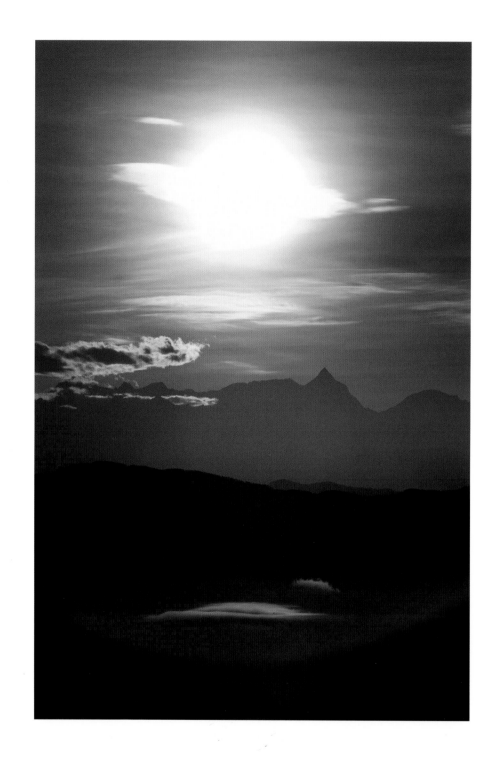

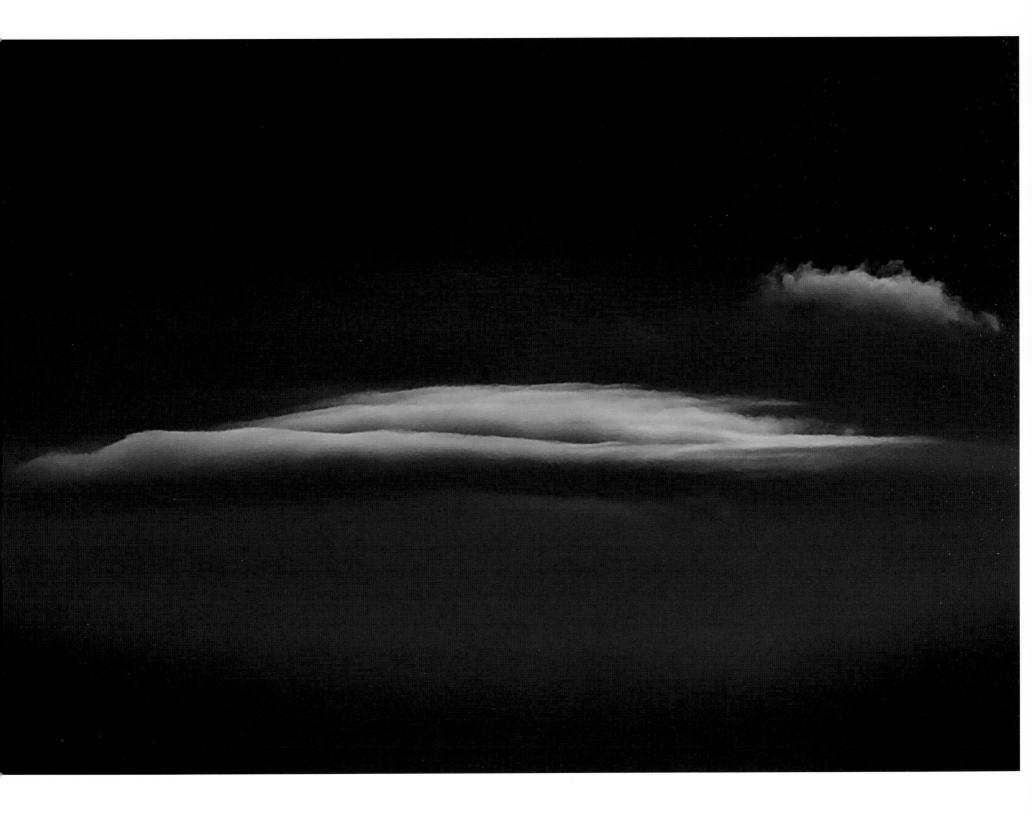

When sunlight falls on a crystal, lights of all colours of the rainbow appear; yet they have no substance that you can grasp. Likewise, all thoughts in their infinite variety are utterly without substance.

Dilgo Khyentse Rinpoche

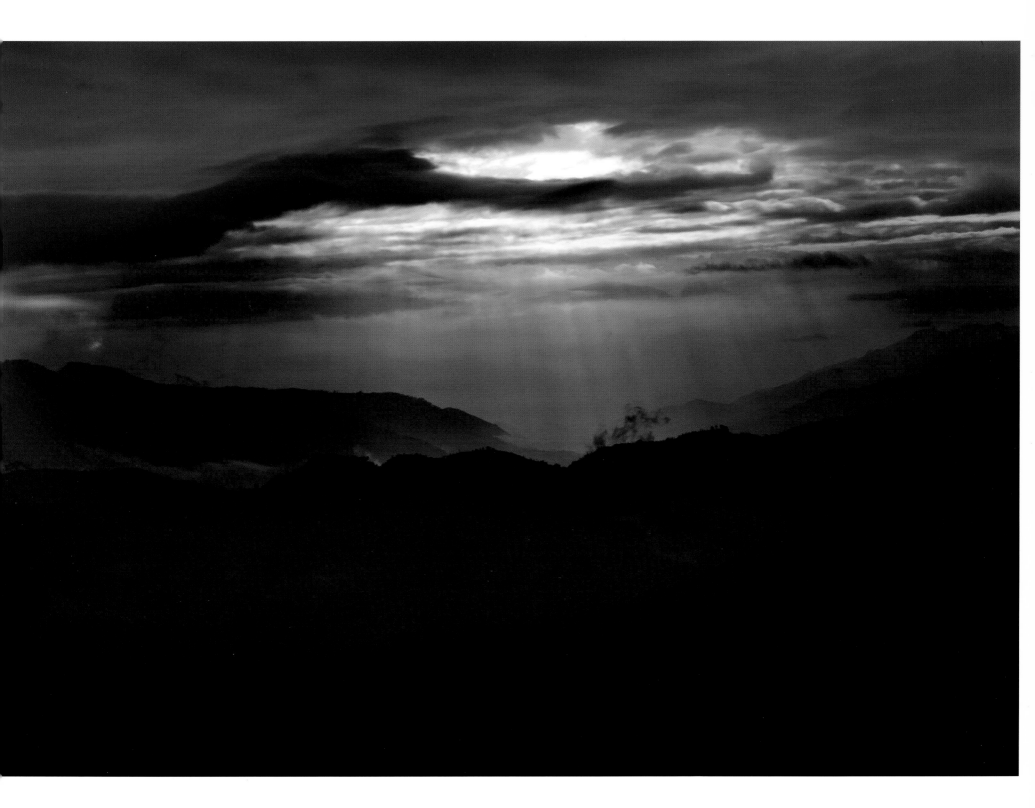

All the joy the world contains

Has come through wishing happiness for others.

All the misery the world contains

Has come through wanting pleasure for oneself.

Shantideva

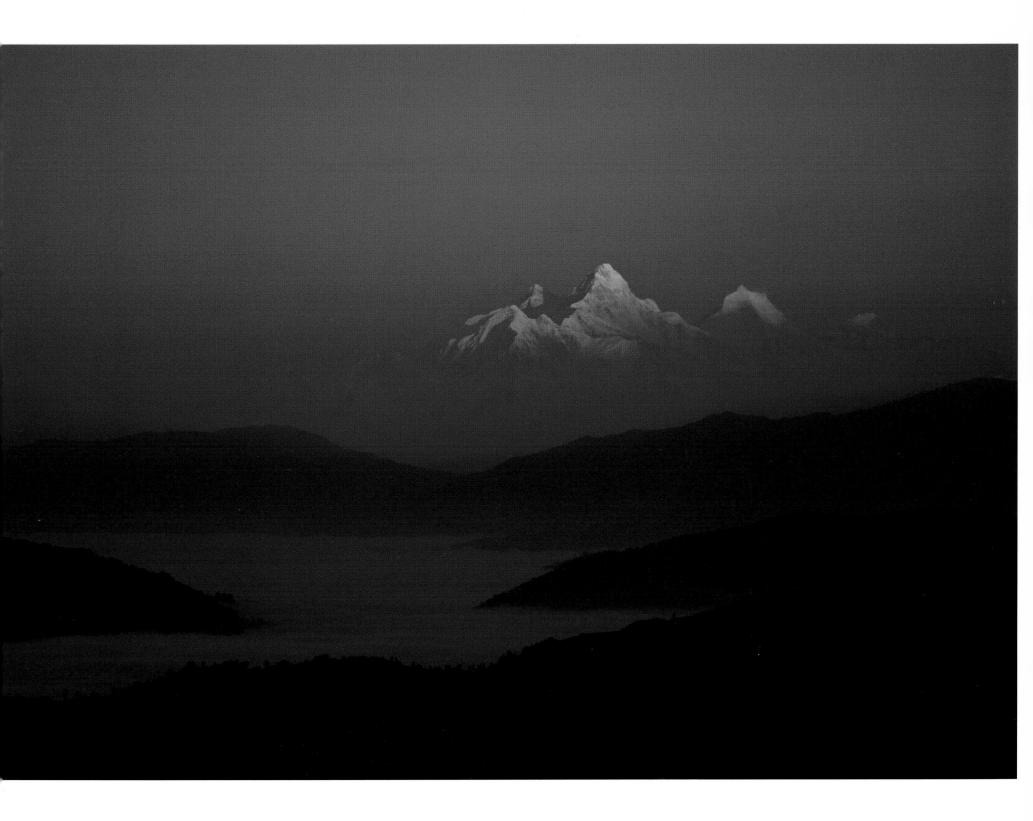

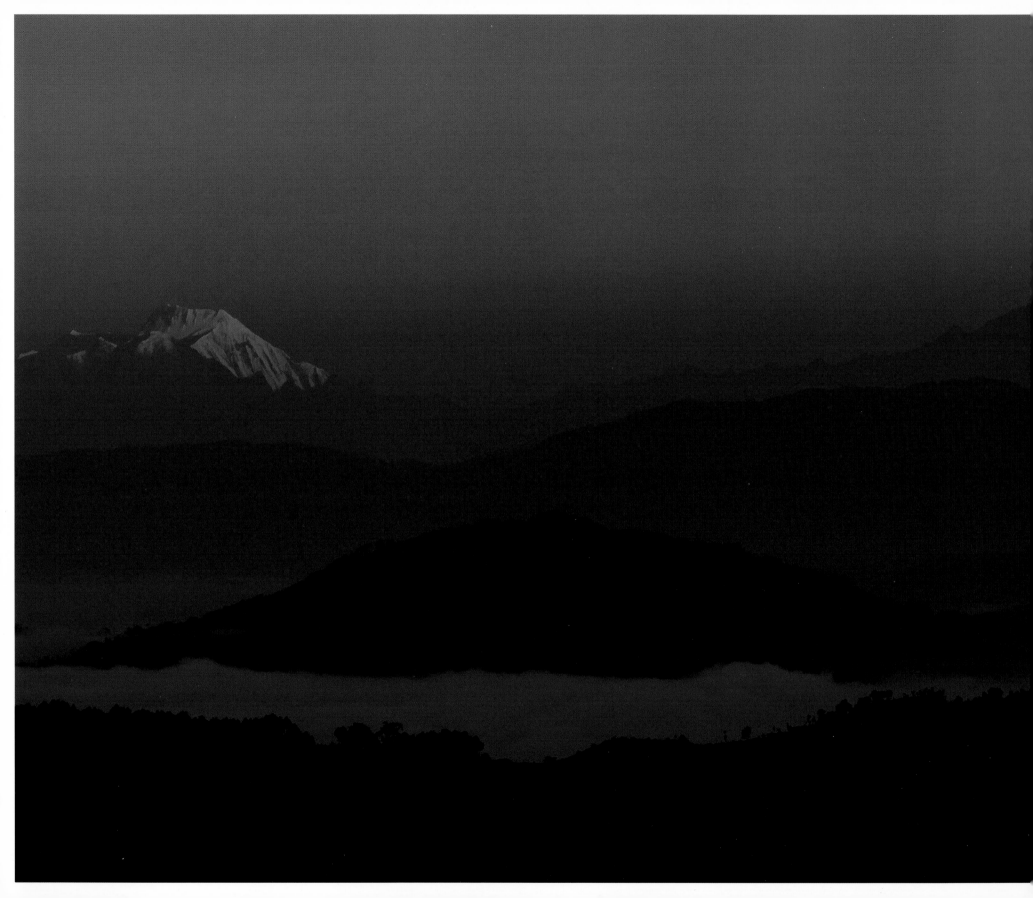

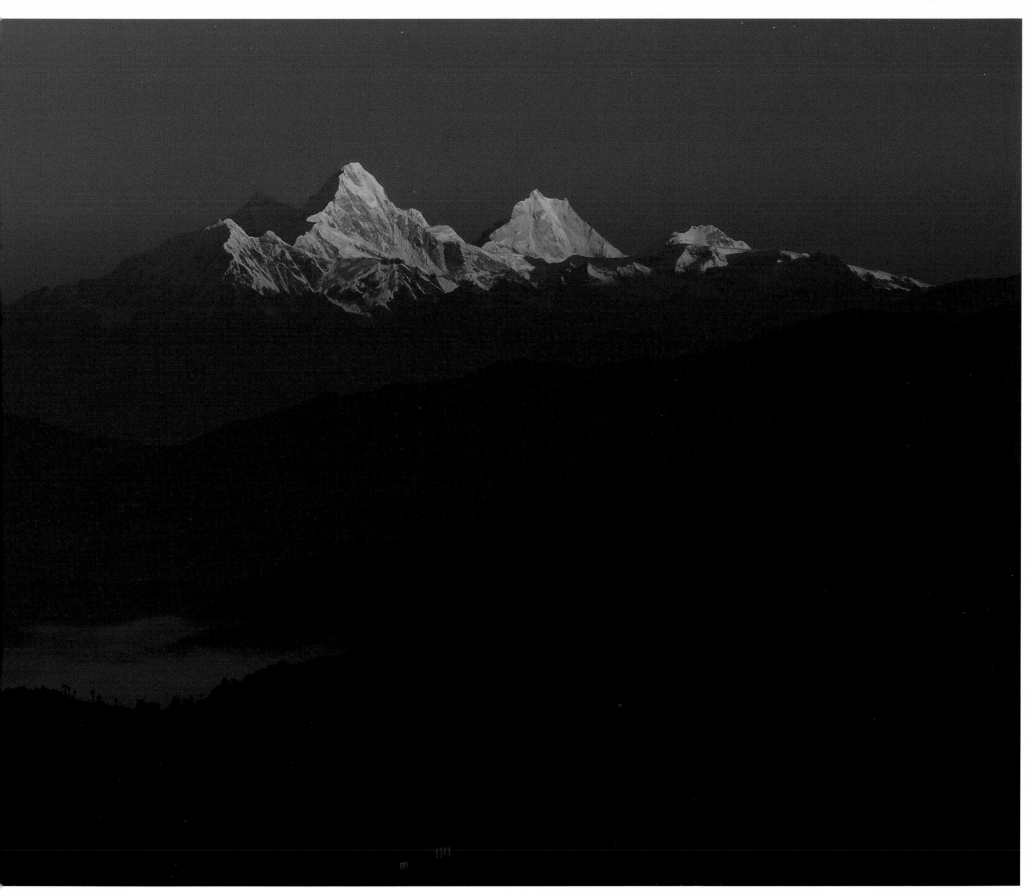

Take care of the minutes, for the hours will take care of themselves.

P. D. Stanhope

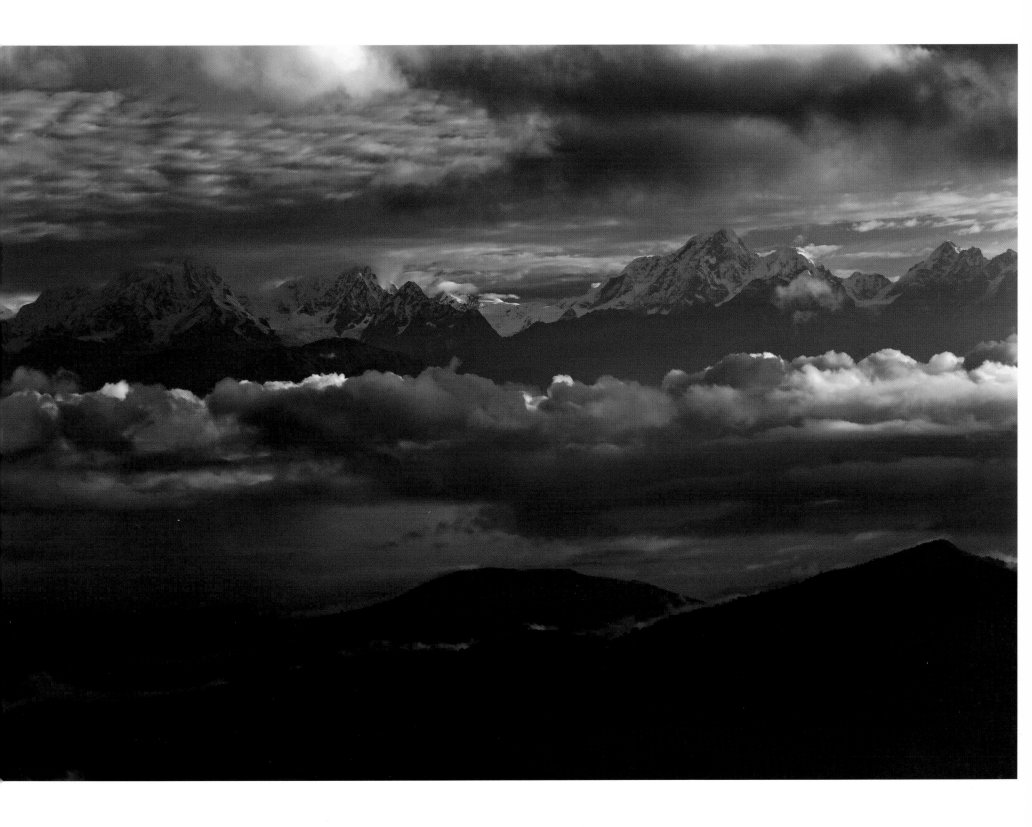

When selfish happiness is the only goal in life, life soon becomes goalless.

Romain Rolland

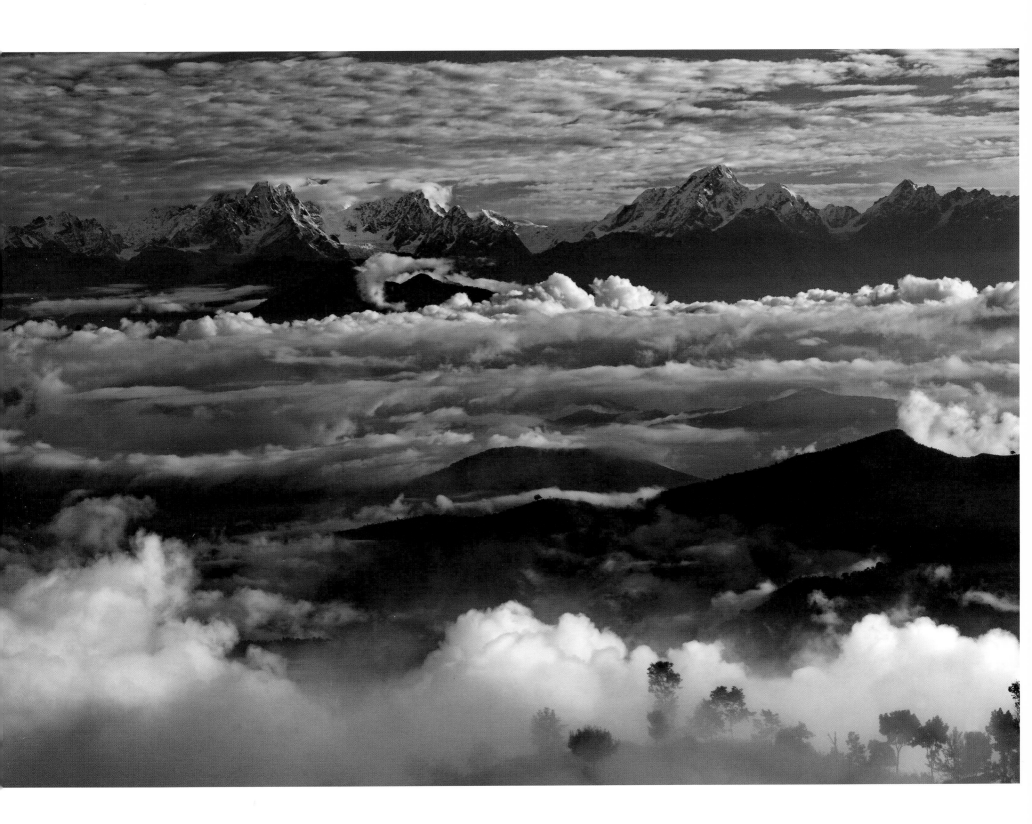

Our life is frittered away by detail… Simplify, simplify!

Henry David Thoreau

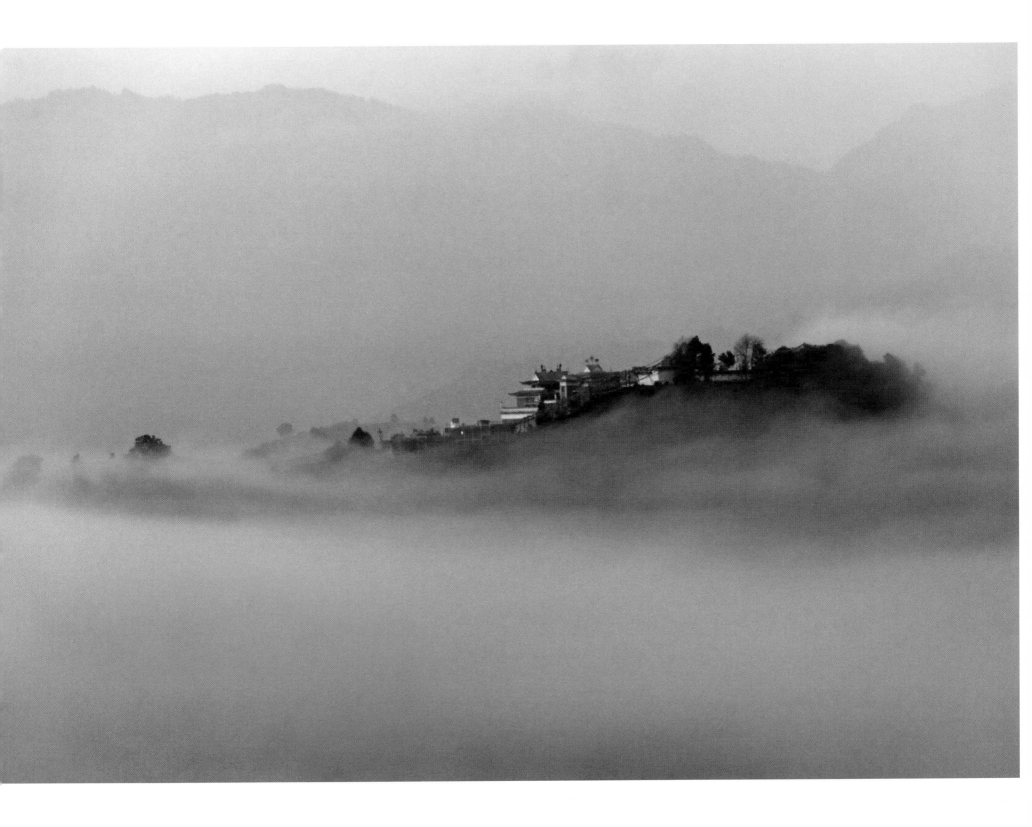

And if their faults are fleeting and contingent,

If living beings are by nature wholesome,

It's likewise senseless to resent them –

As well be angry at the sky for having clouds!

Shantideva

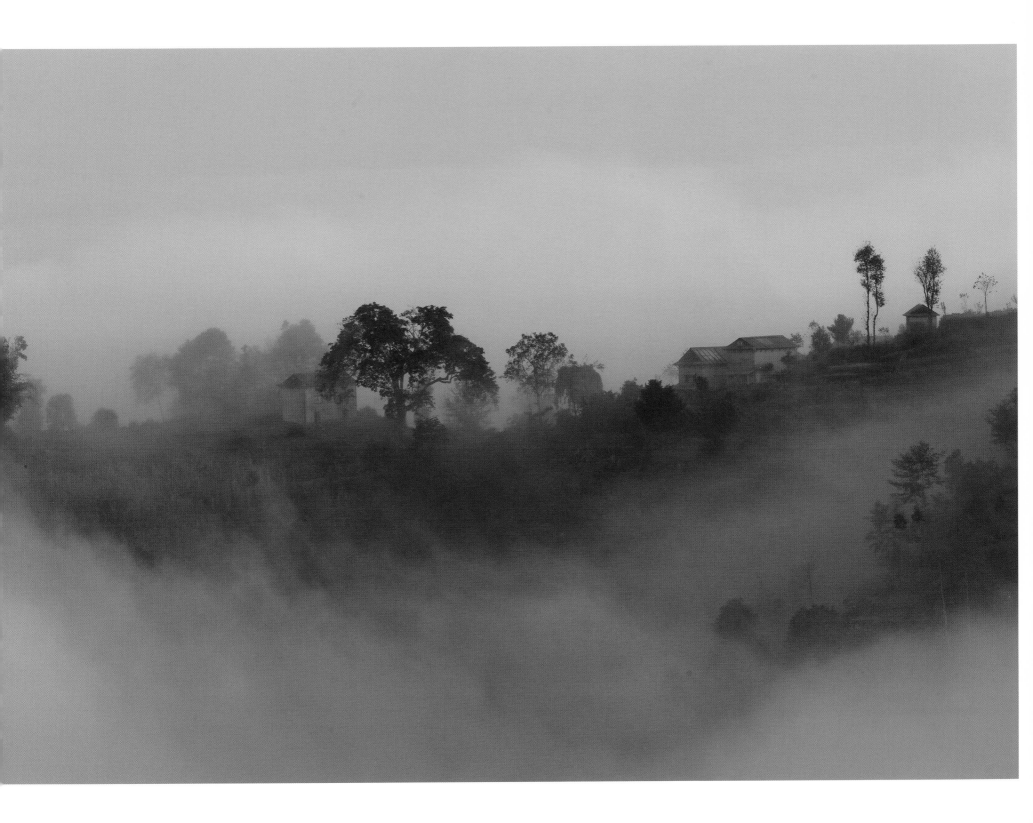

One man dreams he lives a hundred years

Of happiness, but then he wakes.

Another dreams an instant's joy,

But then he, likewise, wakes.

Shantideva

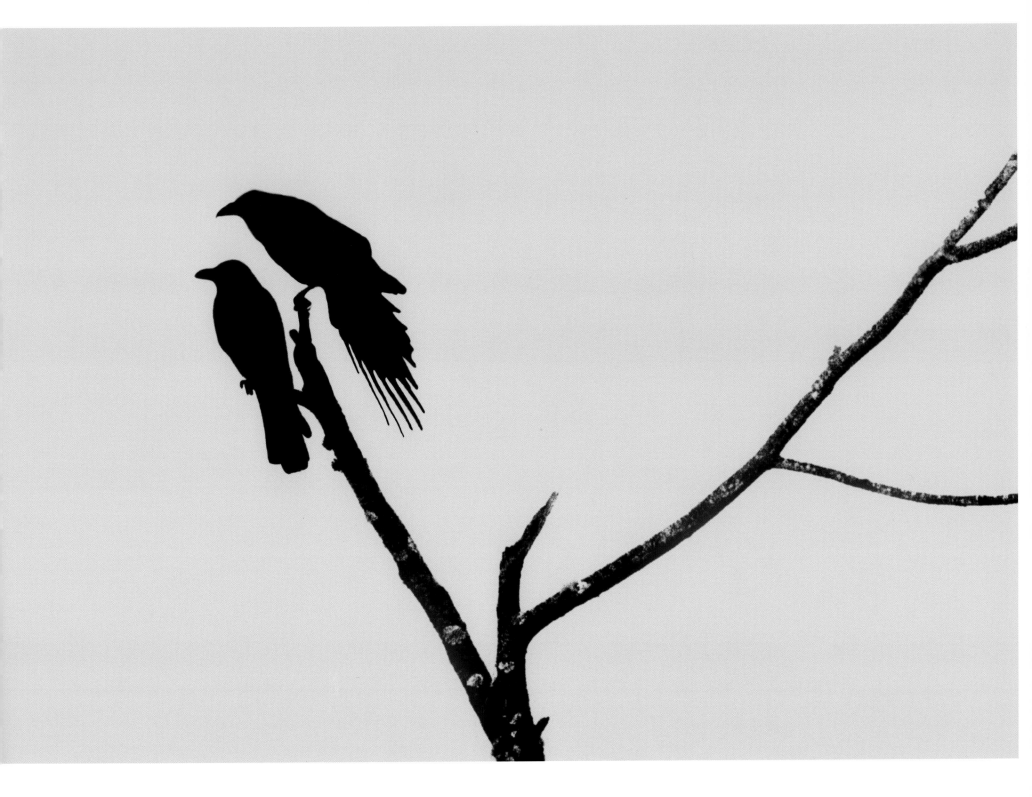

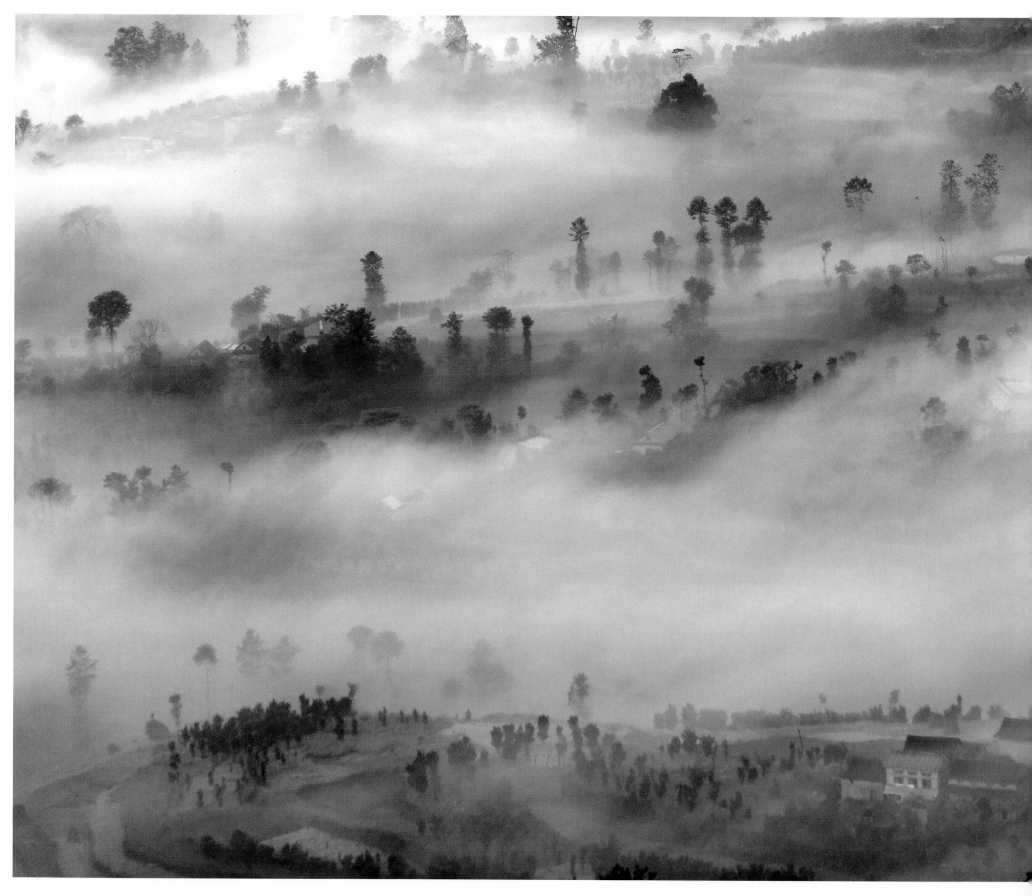

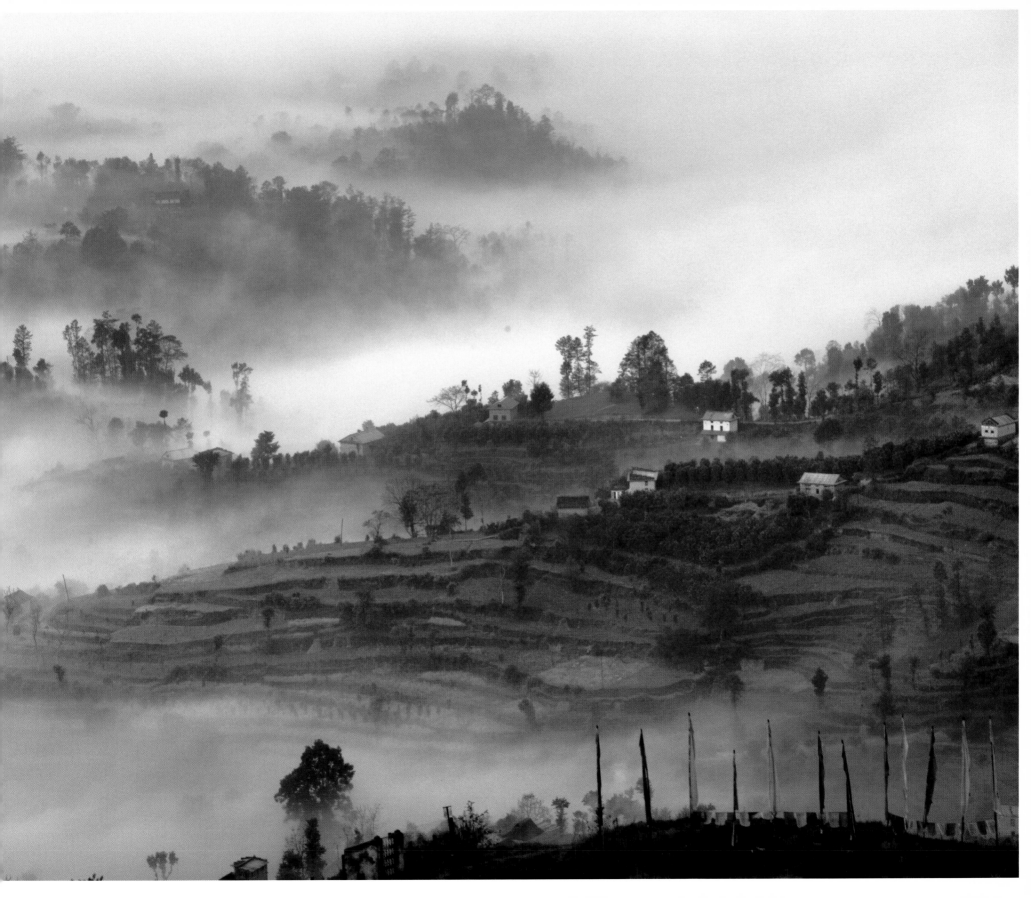

Hatred is the winter of the heart.

Victor Hugo

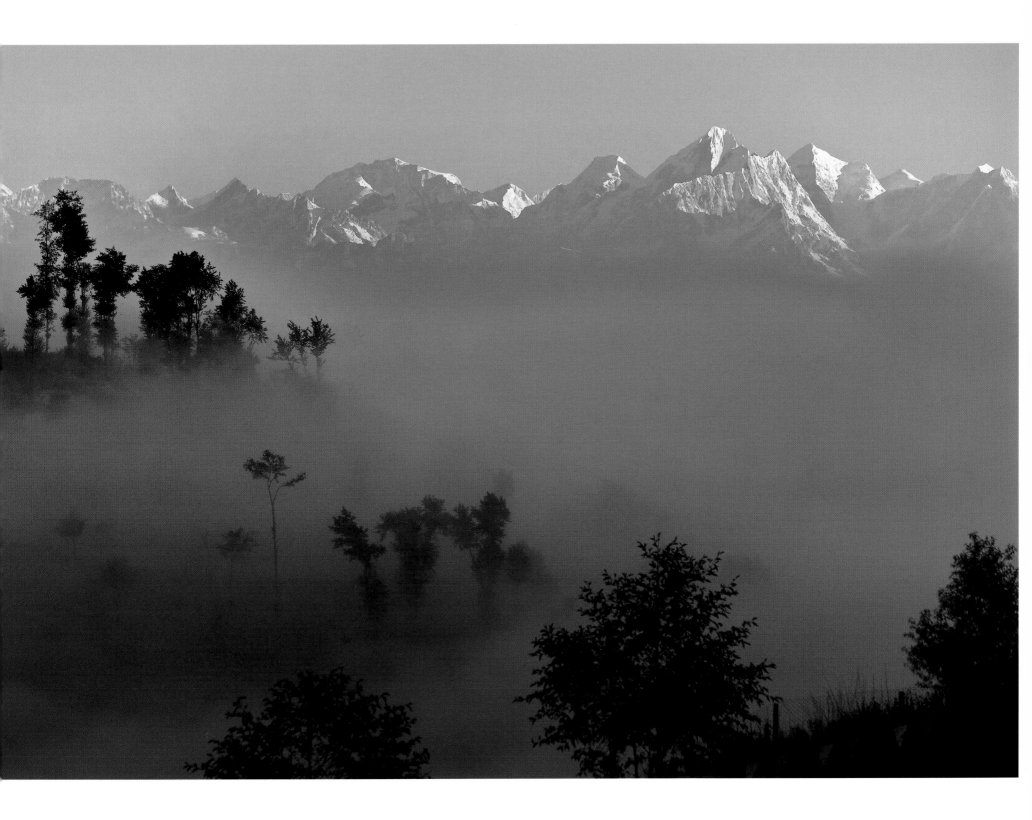

Love is the only thing that increases twofold every time it is shared.

Albert Schweitzer

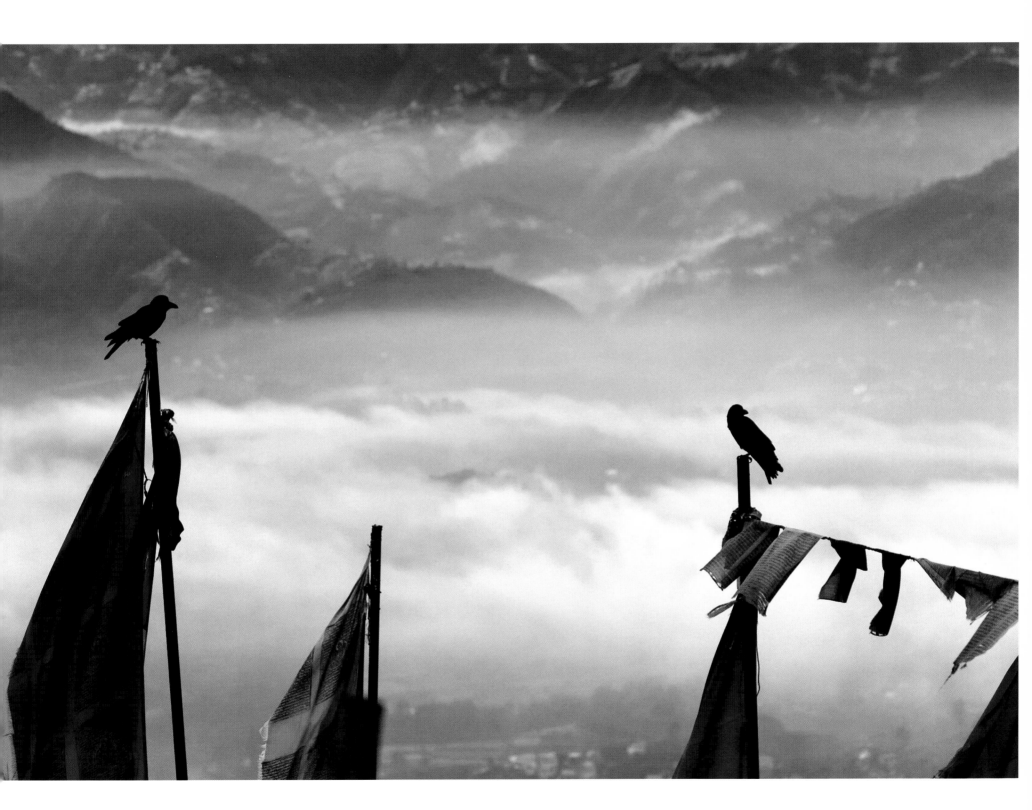

Should I stay in good health, I will use my strength
To dedicate myself to spiritual practice.

Should I fall ill, I will use my troubles
To increase the compassion I feel for those who are suffering.

Should I live long, I will use each moment
To accomplish my own and others' benefit.

Should my life come to its end, I will make the best use of the moment of death
To obtain the right rebirth for pursuing enlightenment.

Tibetan prayer

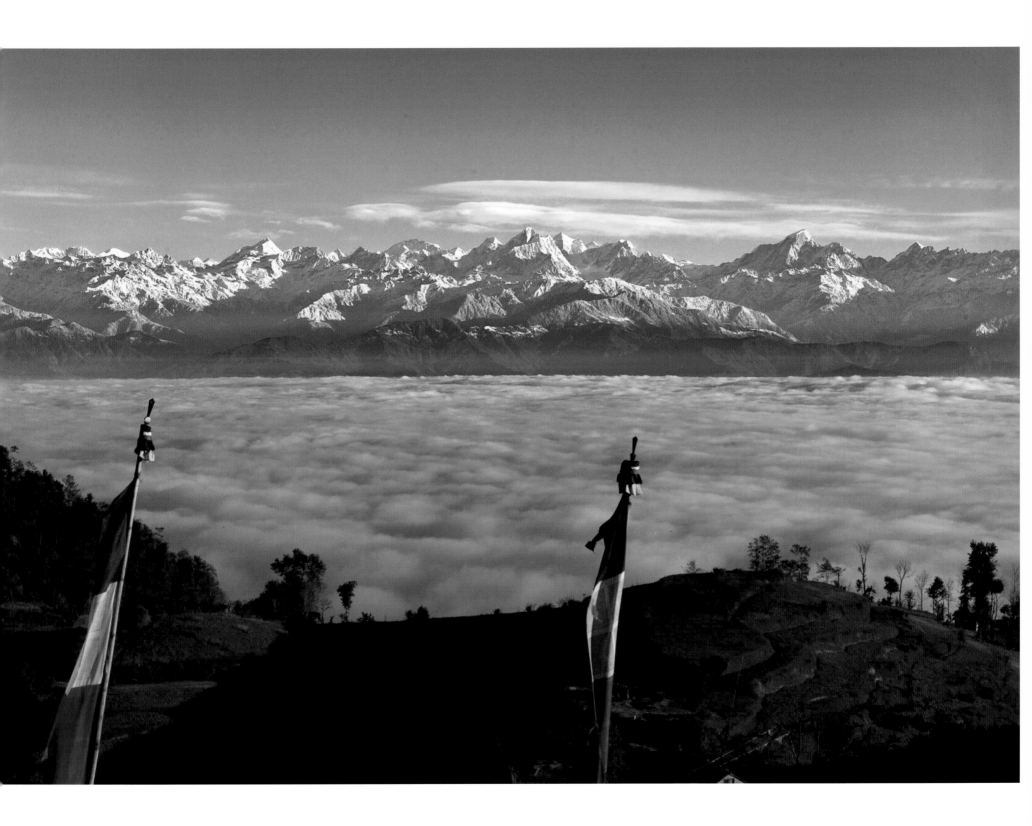

For sentient beings, poor and destitute,

May I become a treasure ever-plentiful,

And lie before them closely in their reach,

A varied source of all that they might need.

Shantideva

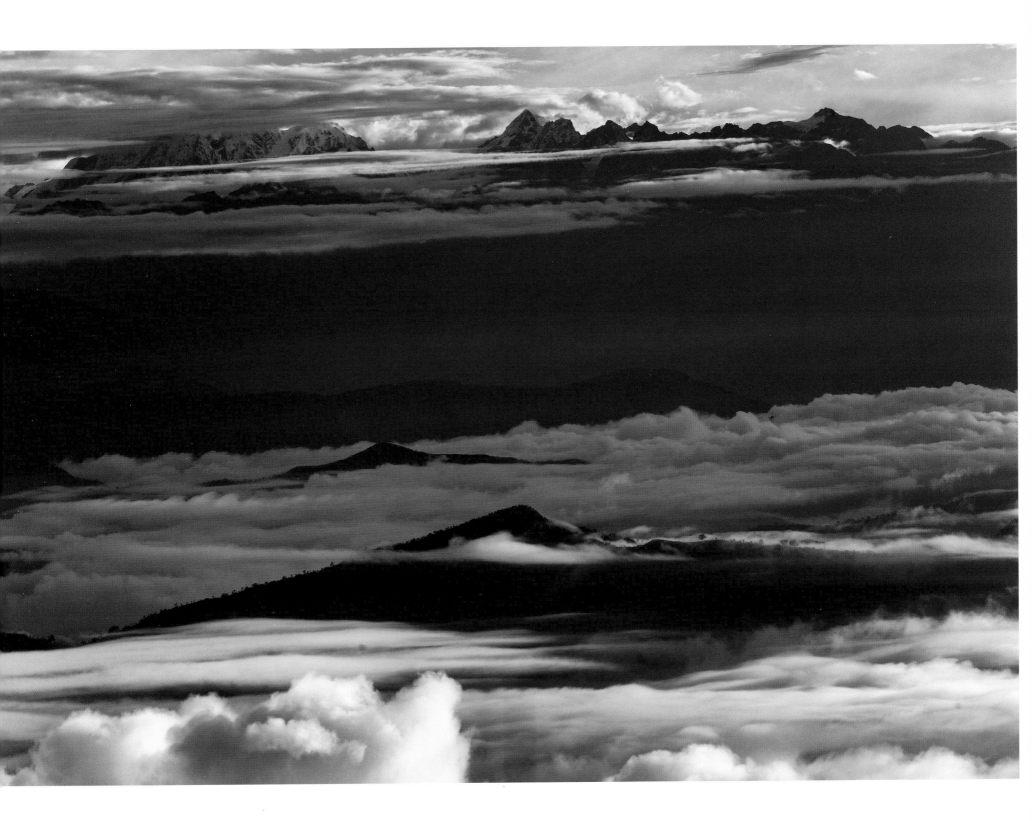

Spending all your life trying to achieve ordinary worldly goals would be like trying to net fish in a dry river-bed. Clearly understanding this, make a firm decision not to allow your life to pursue such a useless course.

Dilgo Khyentse Rinpoche

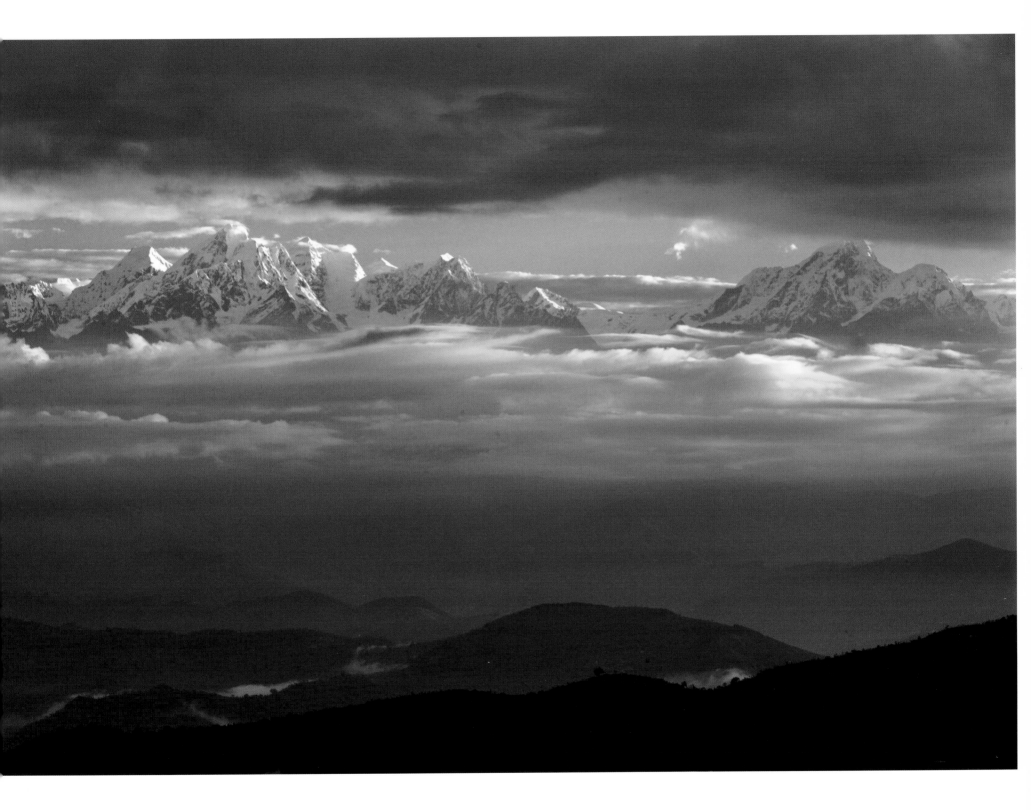

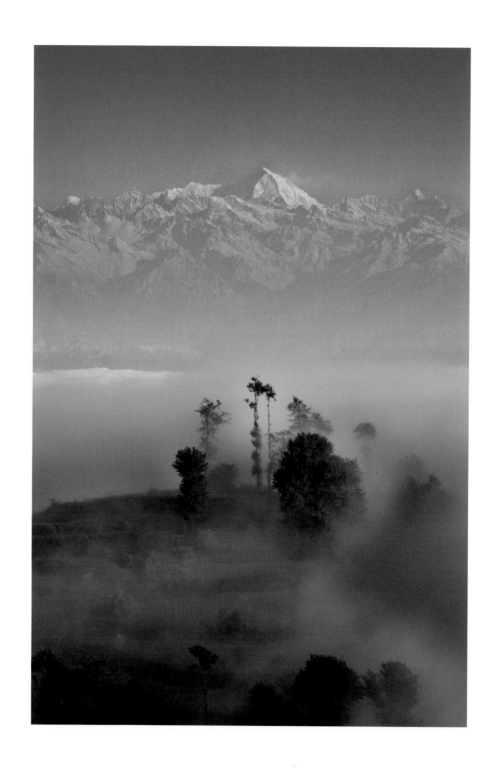

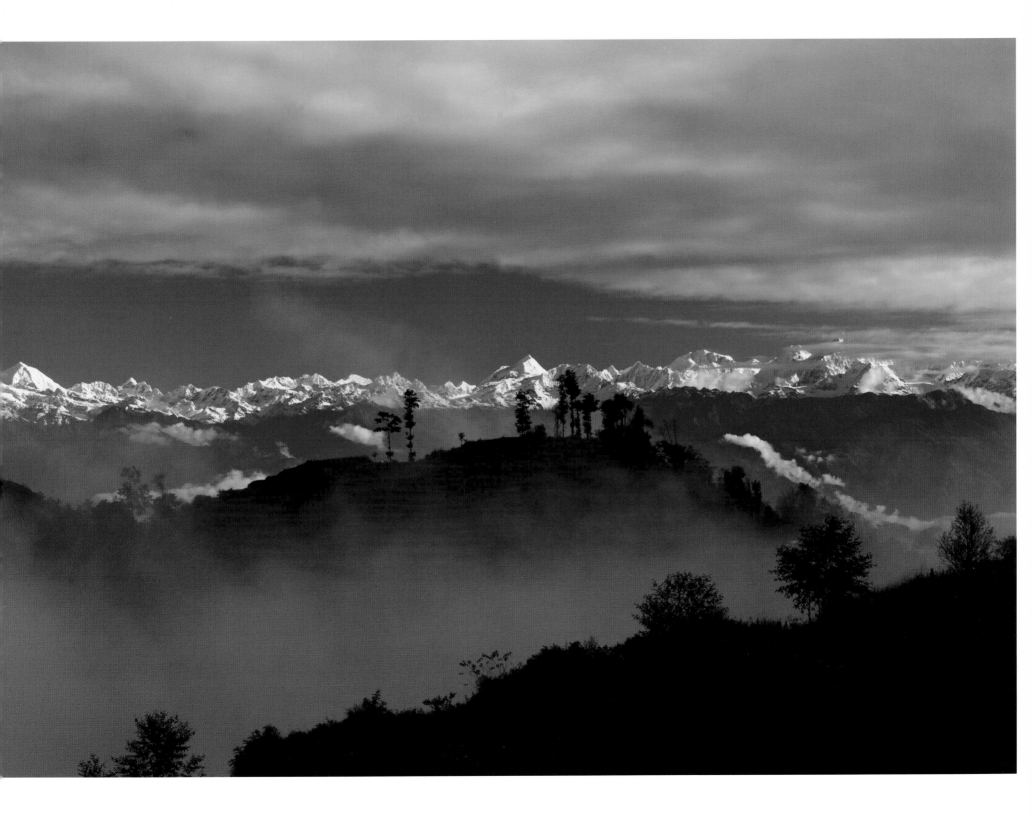

To cover all the earth with sheets of hide –

Where could such amounts of skin be found?

But simply wrap some leather round your feet,

And it's as if the whole earth had been covered!

Shantideva

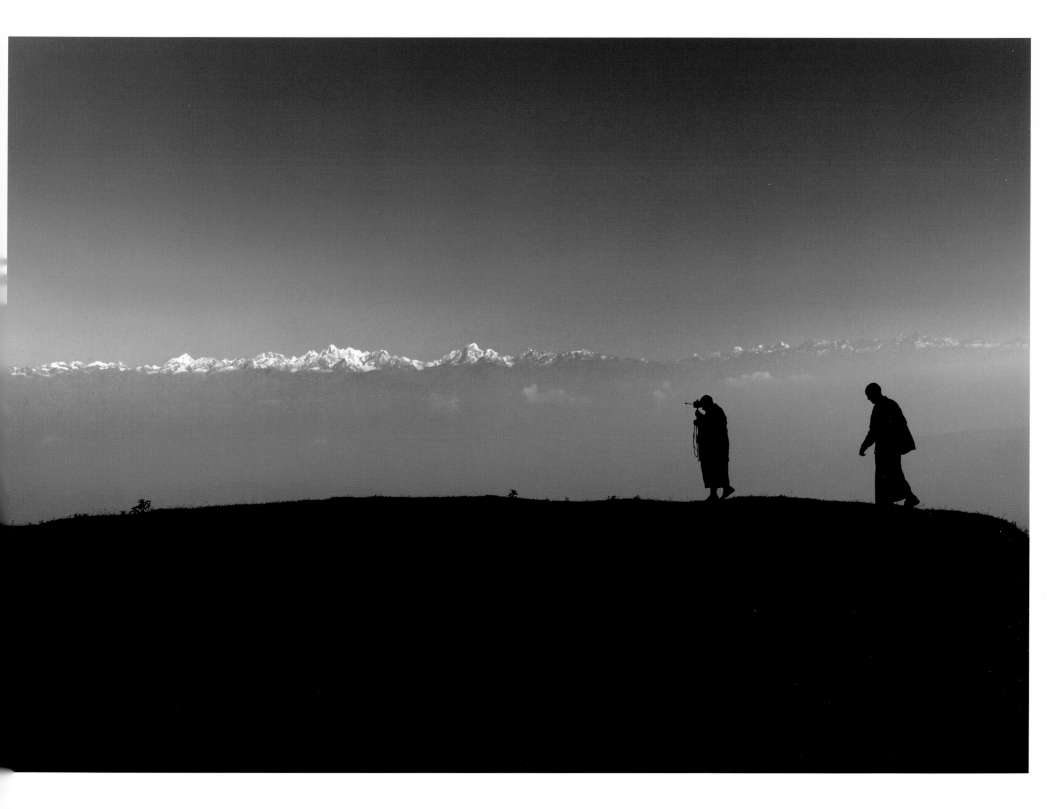

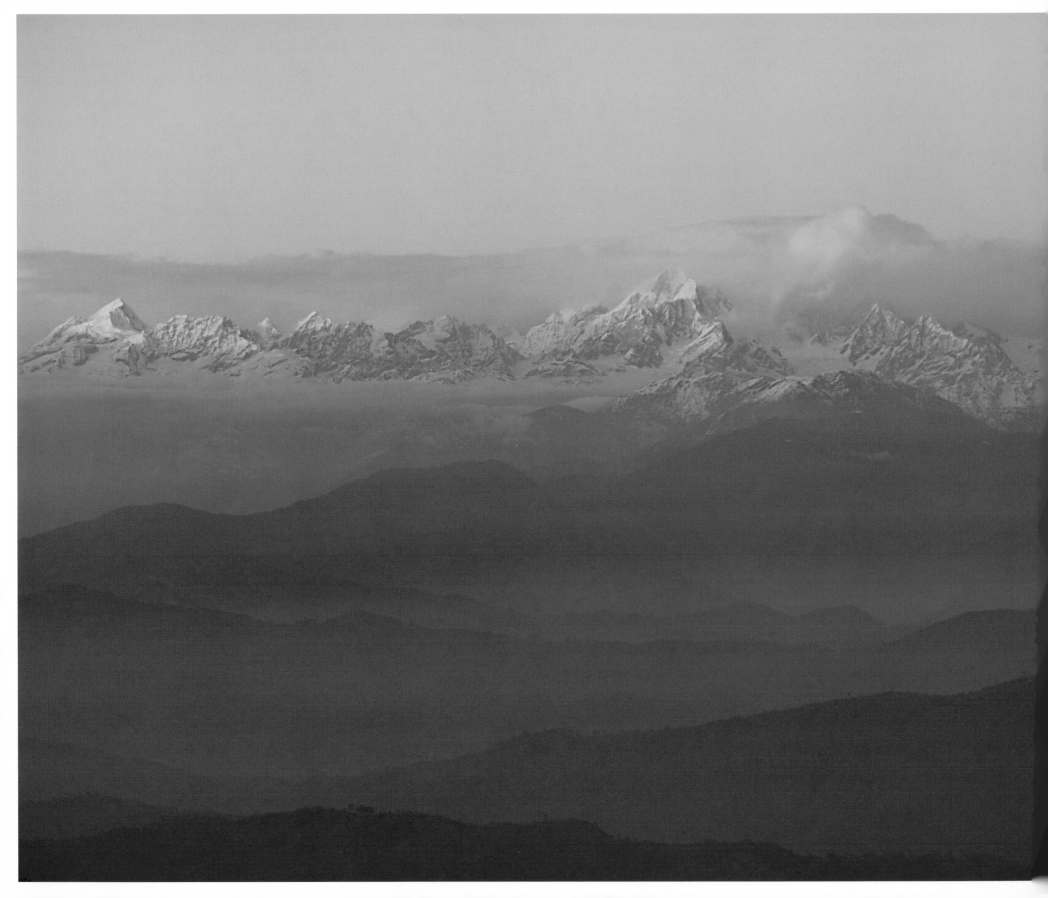

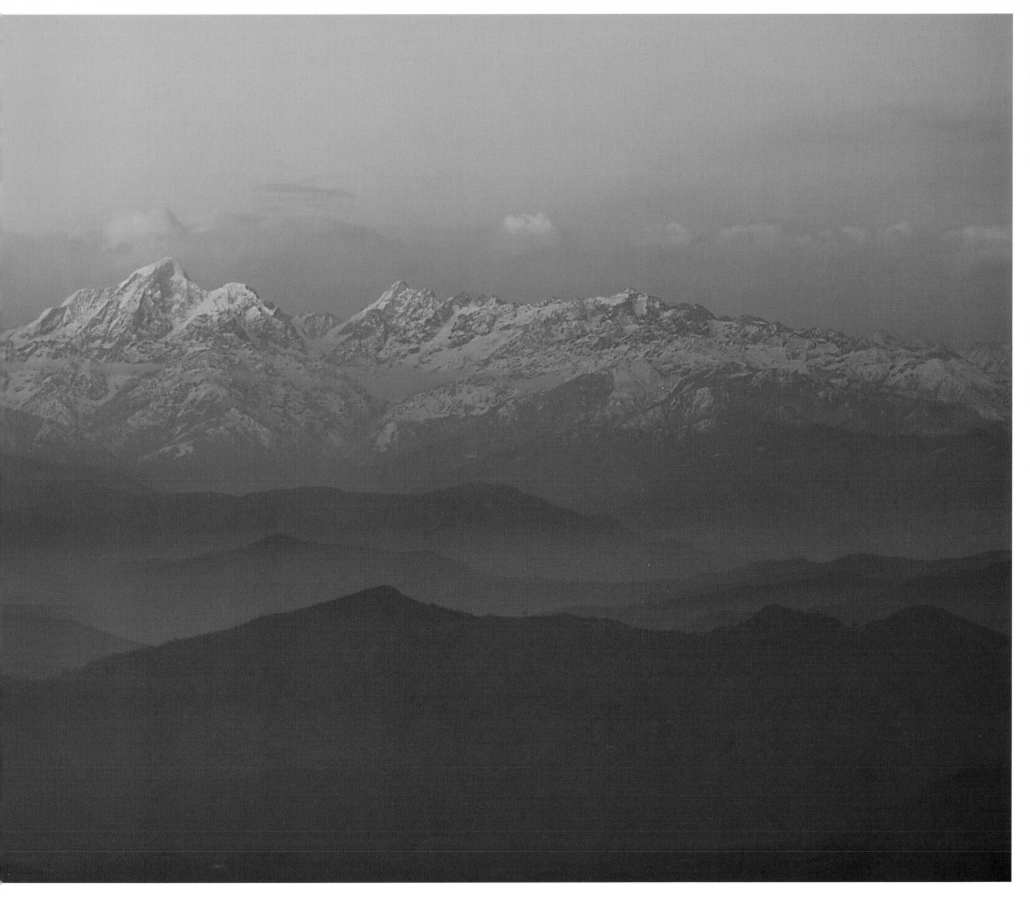

Today I climbed behind
This excellent retreat place.
I raised my head, looking up,
And saw the cloudless sky.

I thought of absolute space, free from limits.
I then experienced a freedom
Without centre, without end,
All biased views
Completely abandoned.

I lowered my head to look in front of me,
And saw the sun of this world.
I thought of meditation
Luminous and unobscured.
I then experienced a non-dual, empty clarity.
All meditations that focus the mind
Completely abandoned.

Shabkar

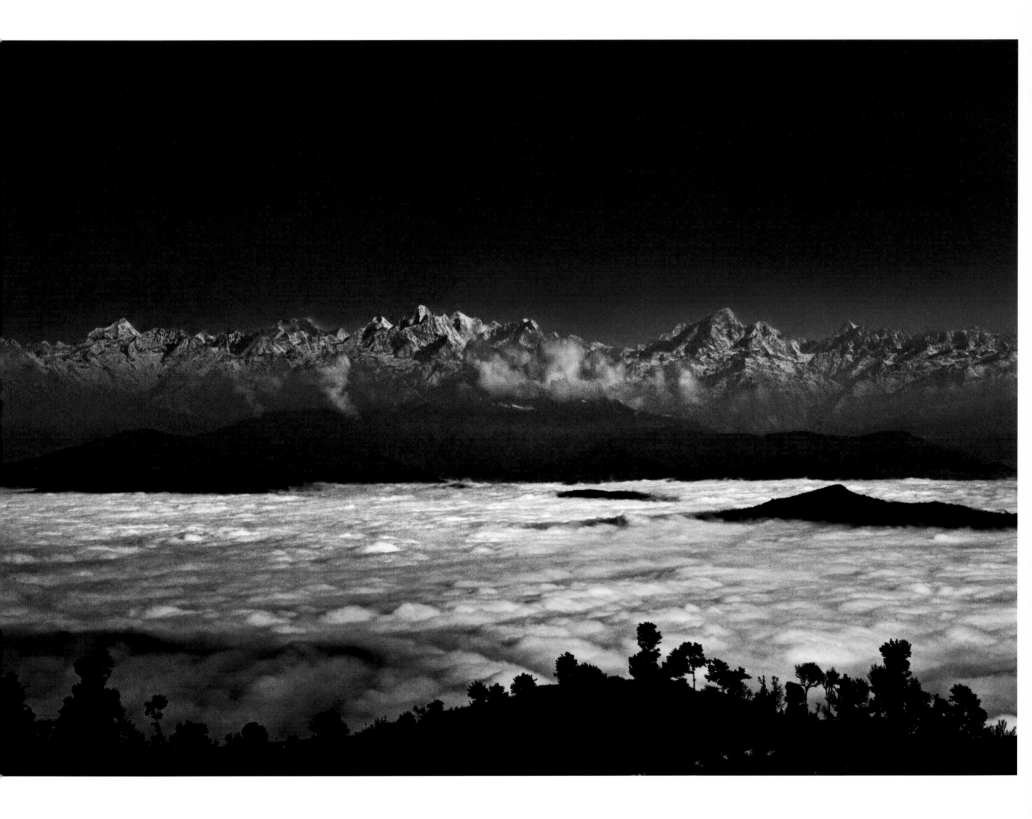

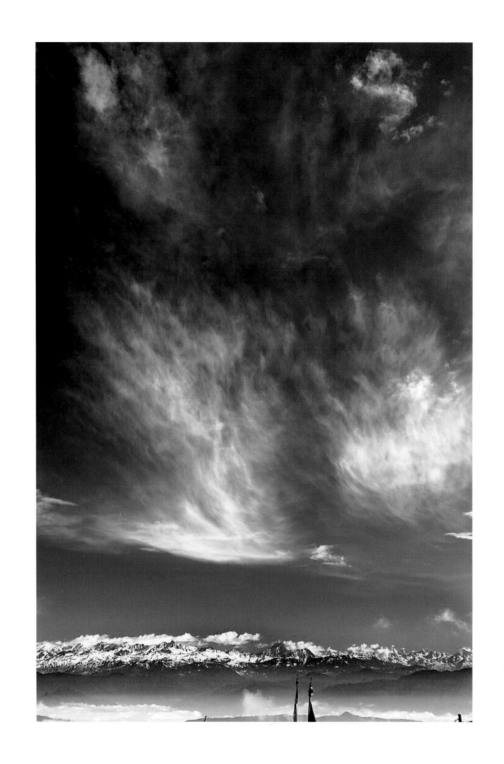

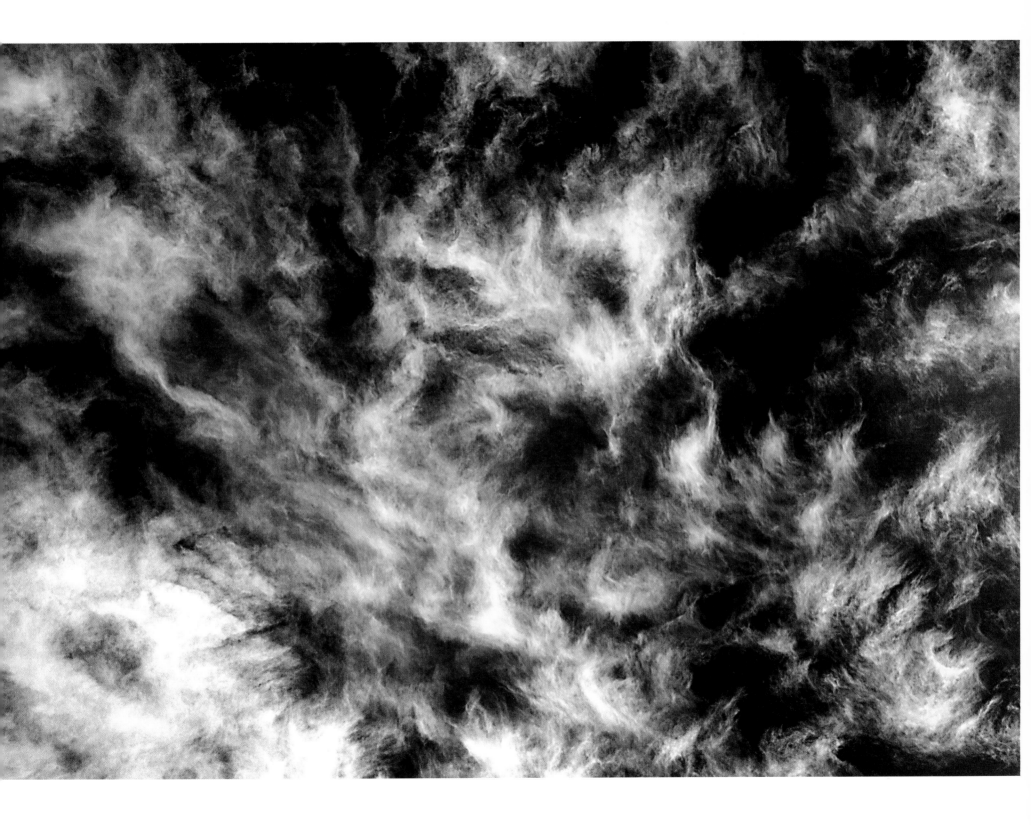

Destroy a single being's joy

And you will work the ruin of yourself.

But if the happiness of all is brought to nothing…

What need is there to speak of this?

Shantideva

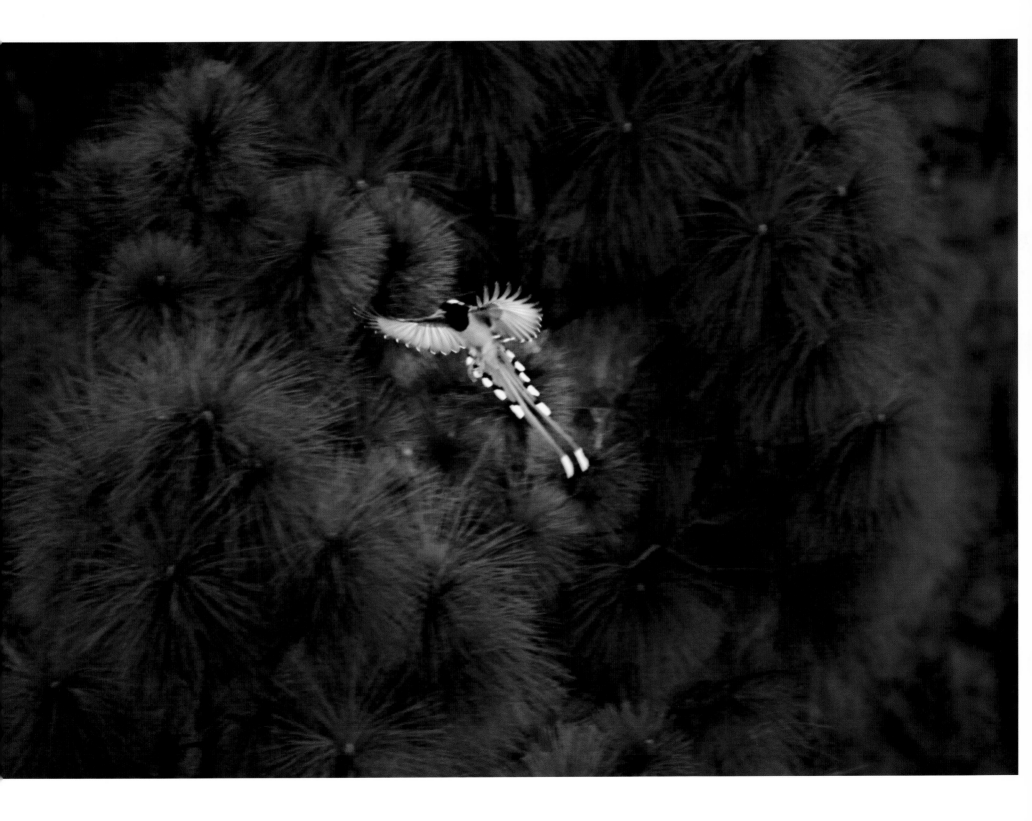

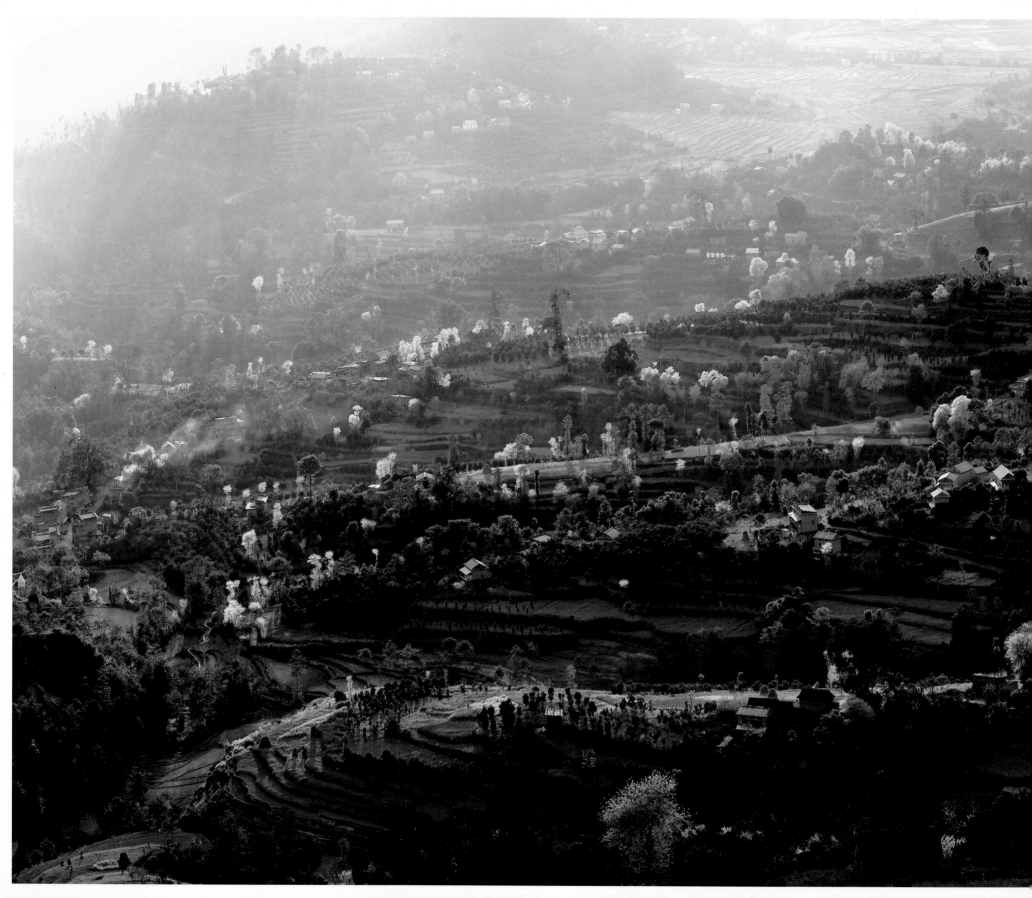

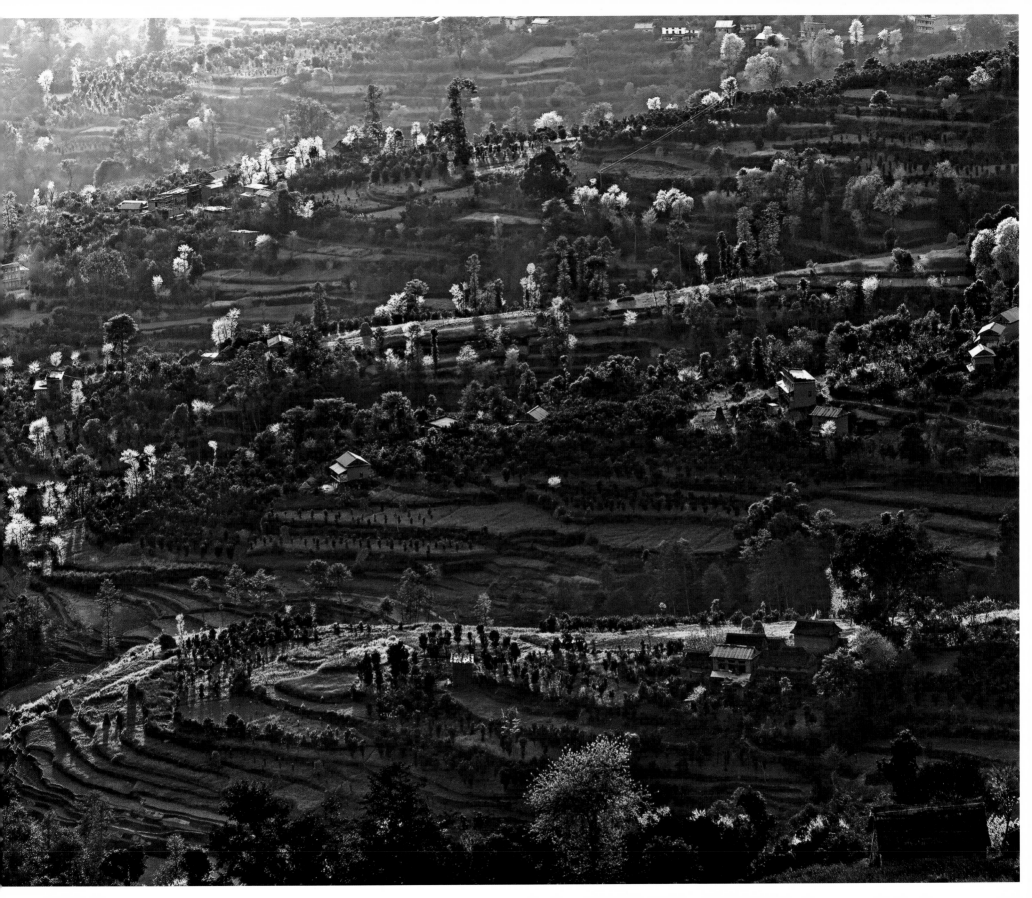

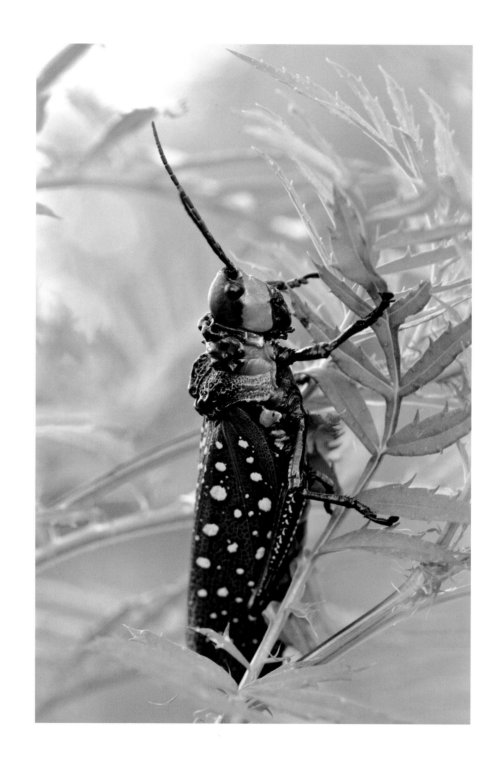

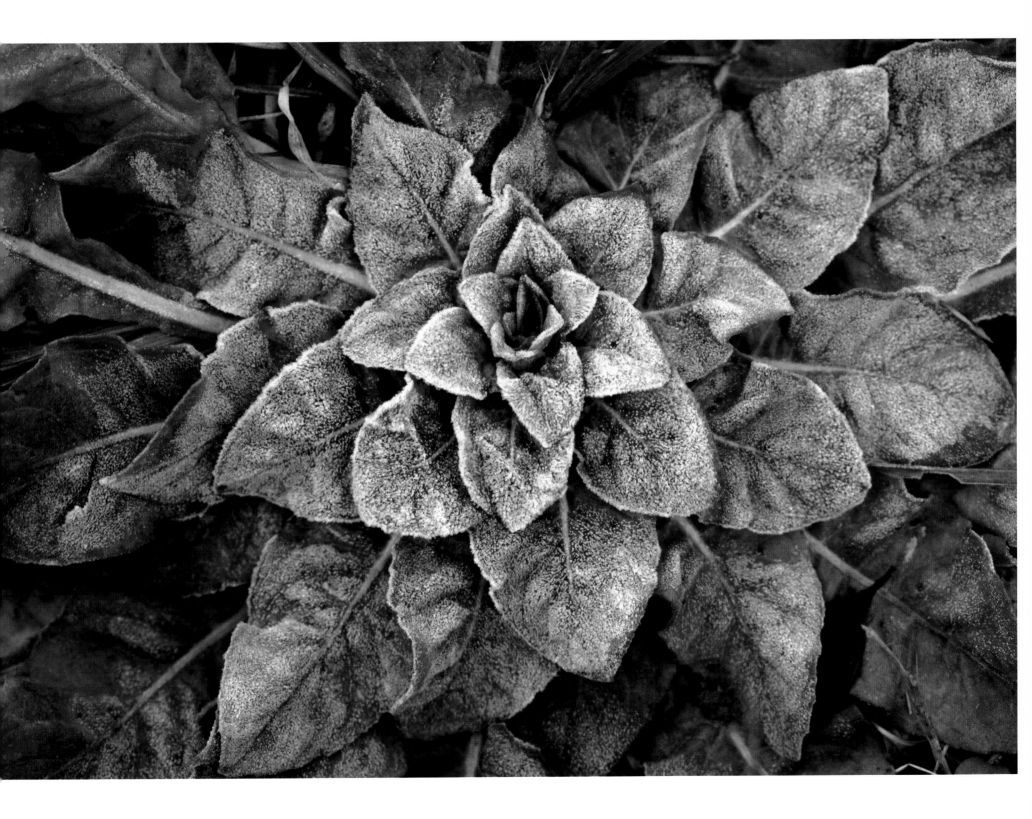

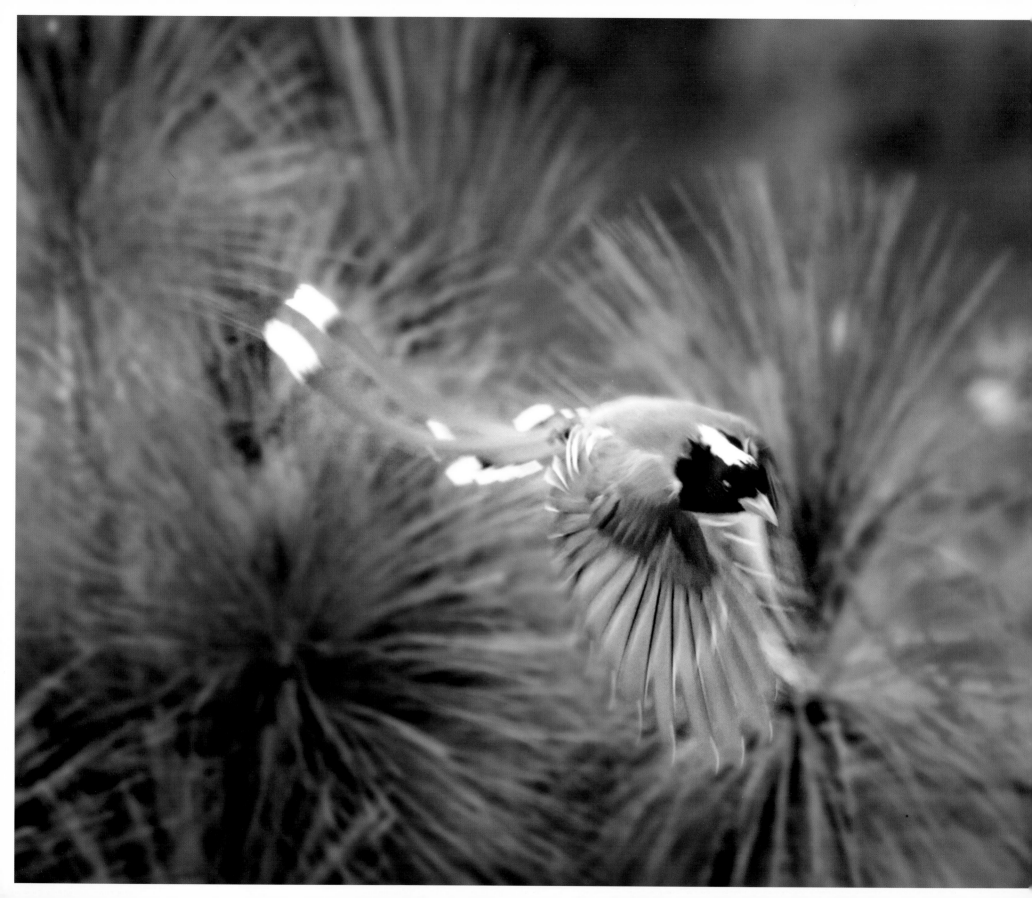

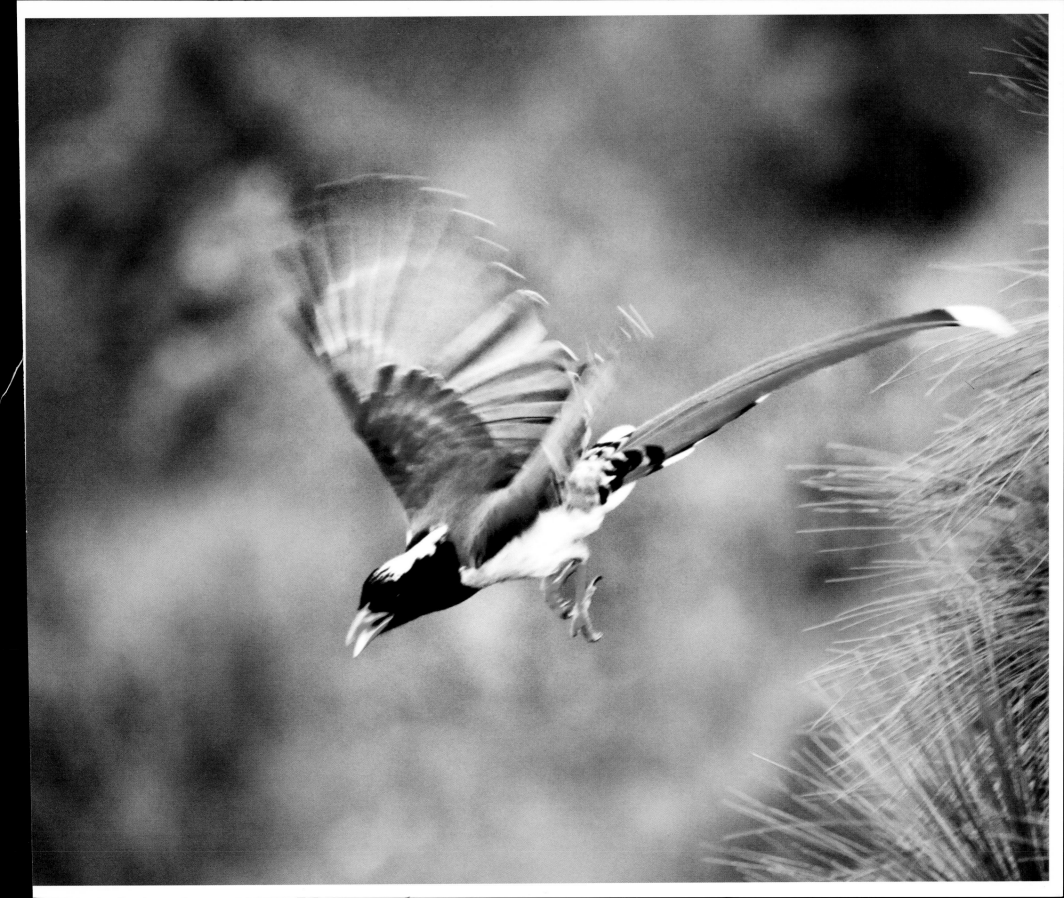

Just as clouds form, last for a while and then dissolve back into the empty sky, so deluded thoughts arise, remain for a while and then vanish in the voidness of mind; in reality nothing at all has happened.

Dilgo Khyentse Rinpoche

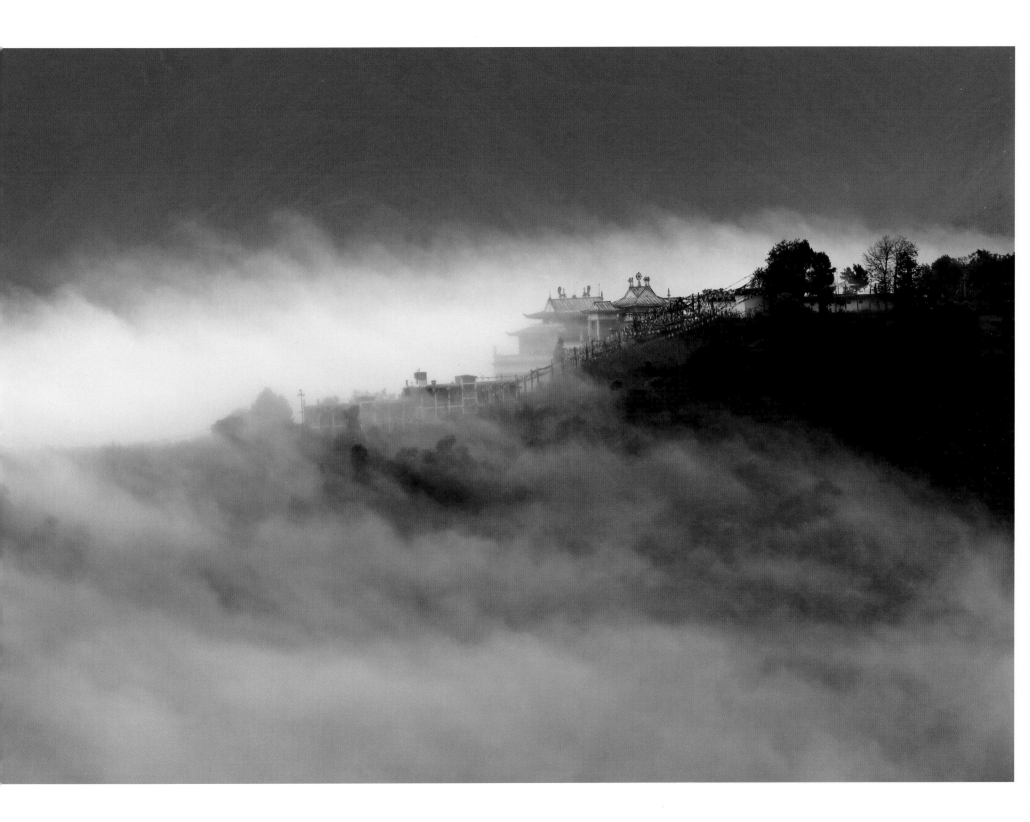

As long as space endures,

And as long as sentient beings exist,

May I, too, remain

To dispel the misery of the world.

Shantideva

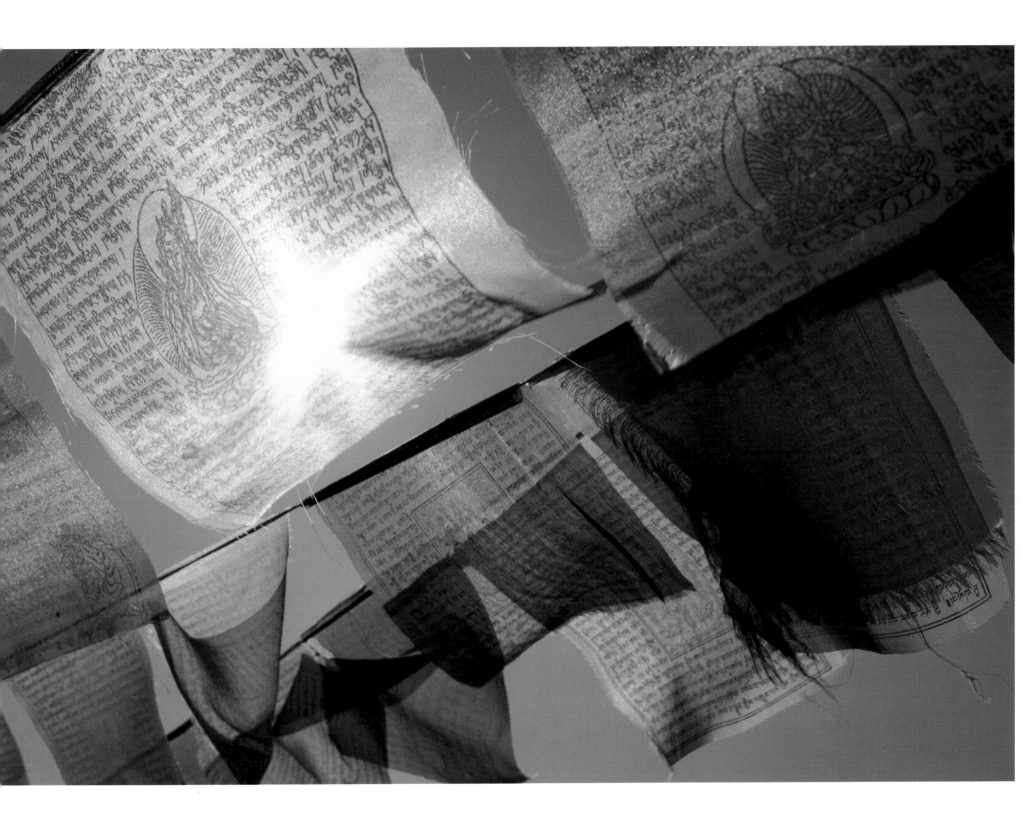

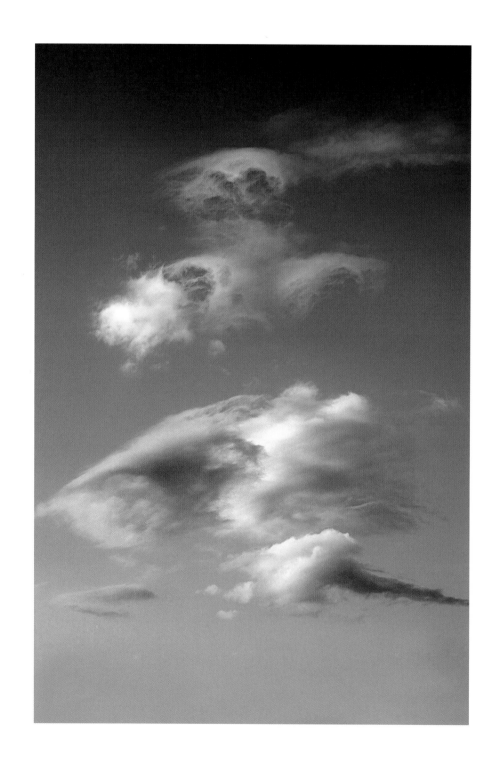

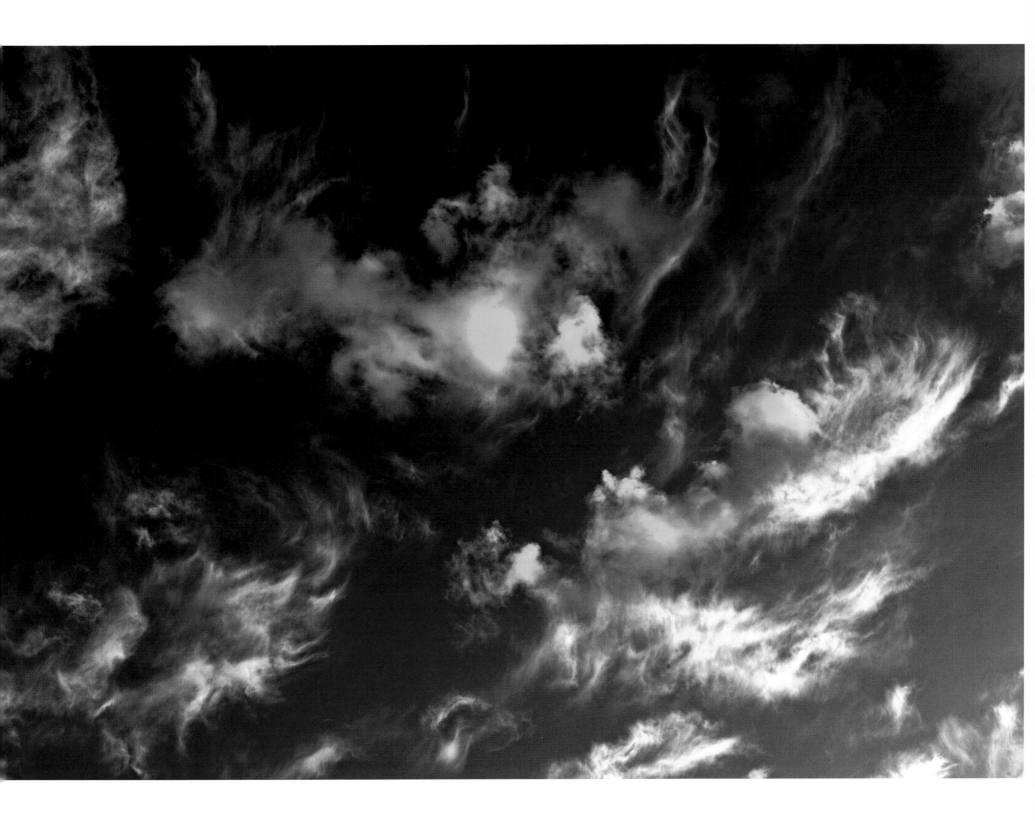

To expect happiness without giving up negative action is like holding your hand in a fire and hoping not to be burned.

Dilgo Khyentse Rinpoche

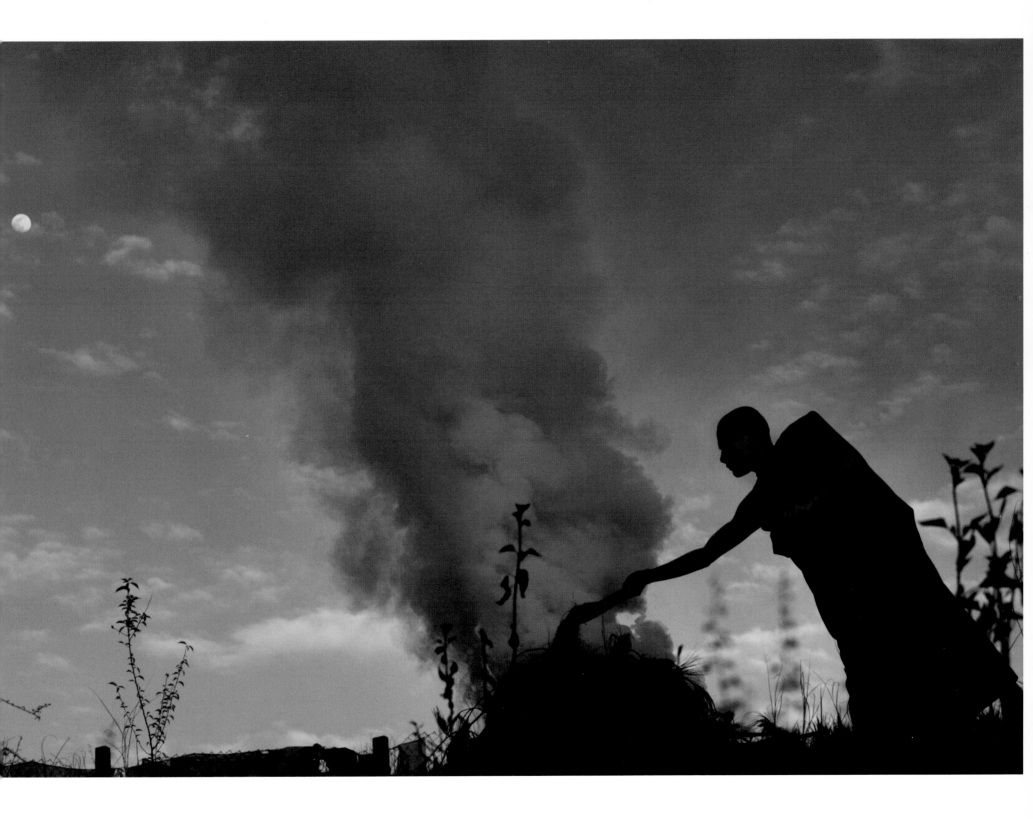

Those who are tormented by the summer heat

Long for the moonlight of autumn.

And if not overcome by fear, it is because the thought has not crossed their minds

That another hundred days of their life will have passed.

Jetsun Milarepa

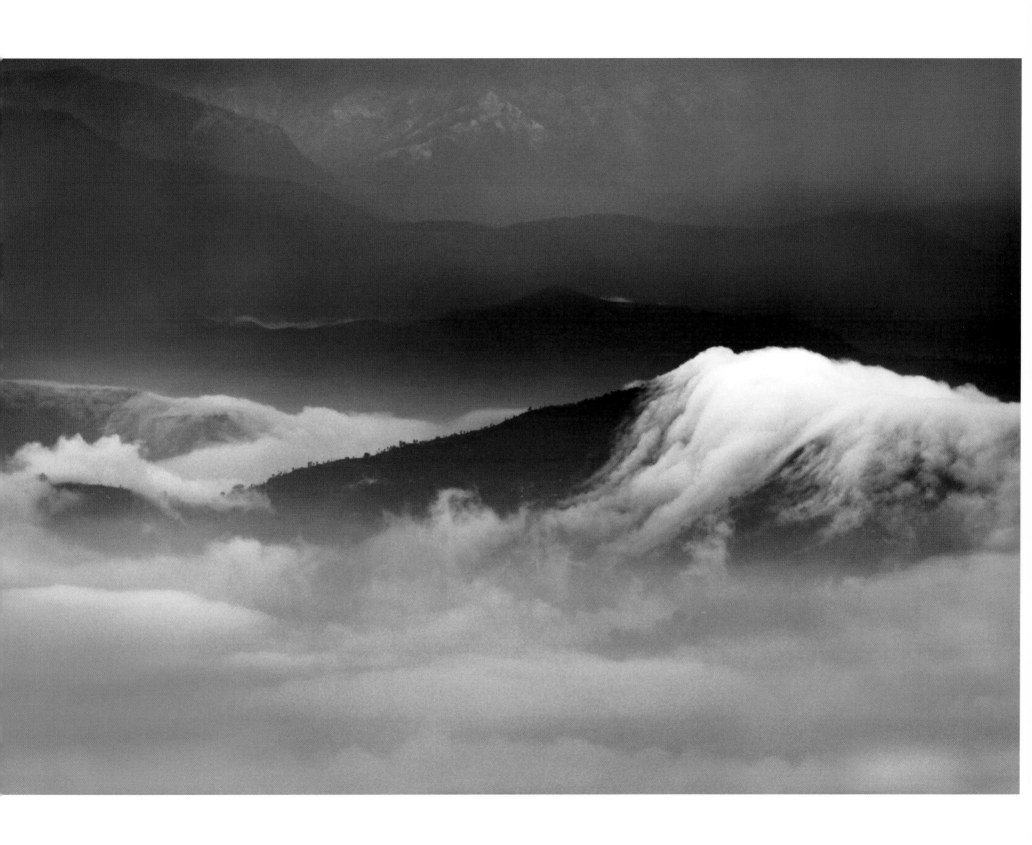

What a relief it is for the burdened man who has long walked through the world of suffering to lay down his heavy and useless load.

Longchen Rabjam

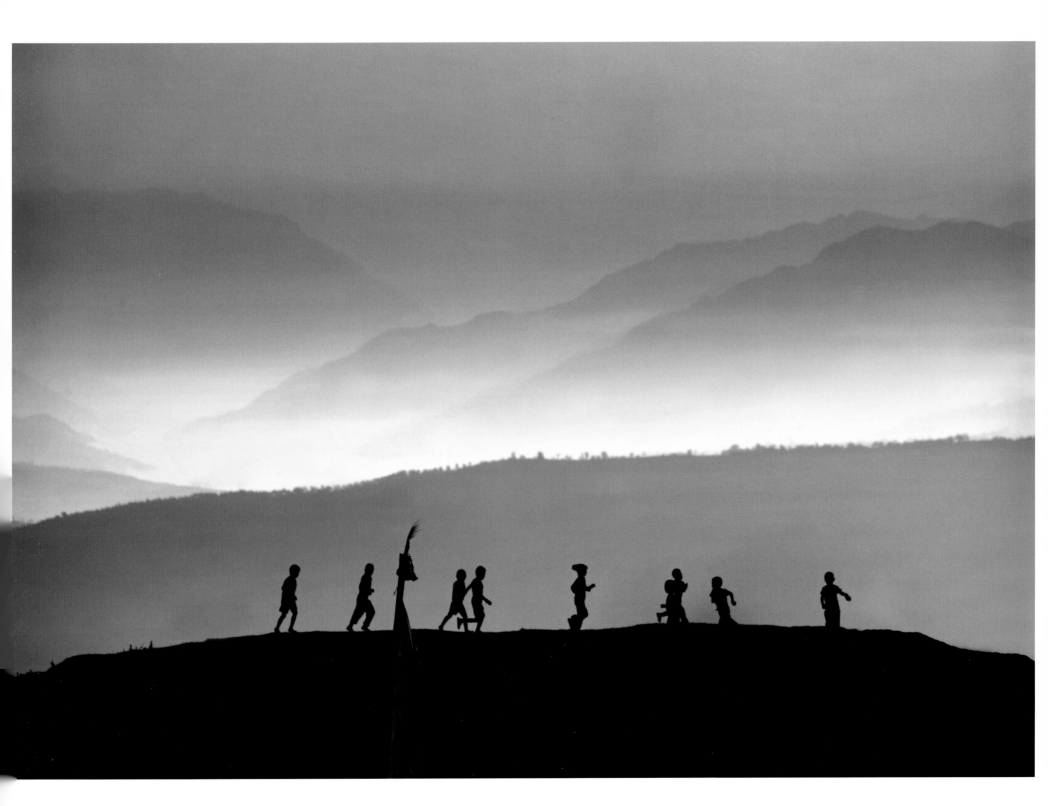

If you allow your thoughts and feelings to arise and dissolve by themselves,
they will pass through your mind in the same way as a bird flies through the sky, without leaving any trace.

Dilgo Khyentse Rinpoche

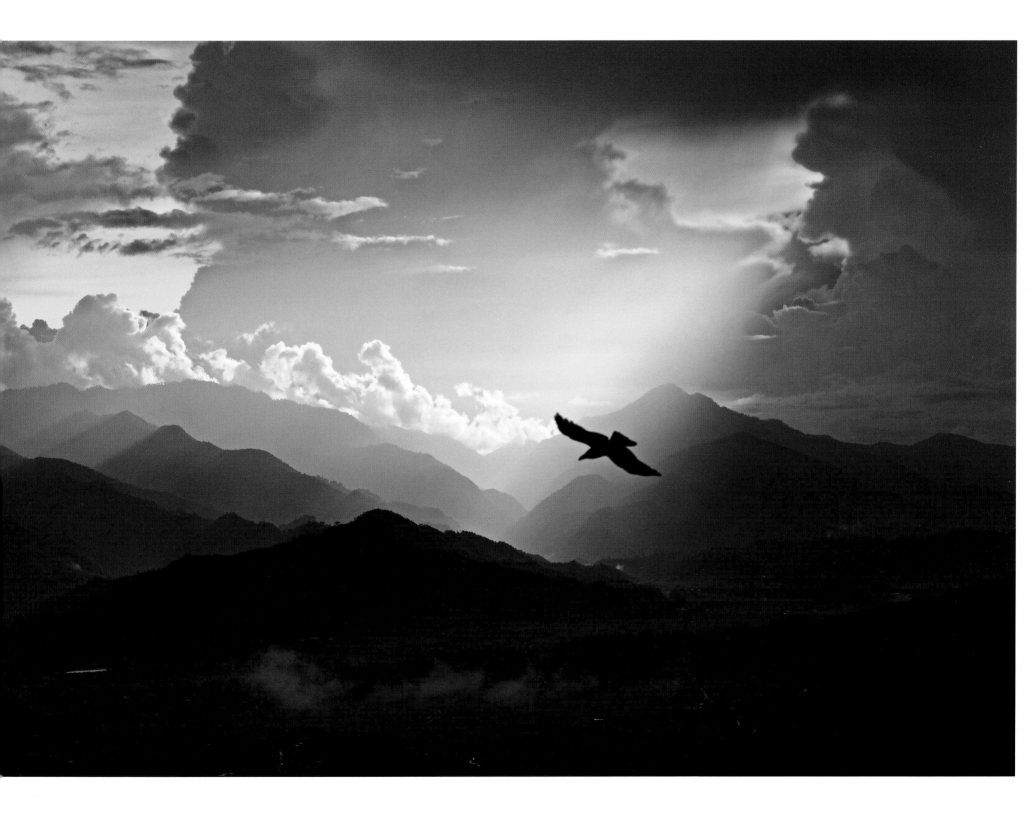

Look within. Within is the fountain of good.

Marcus Aurelius

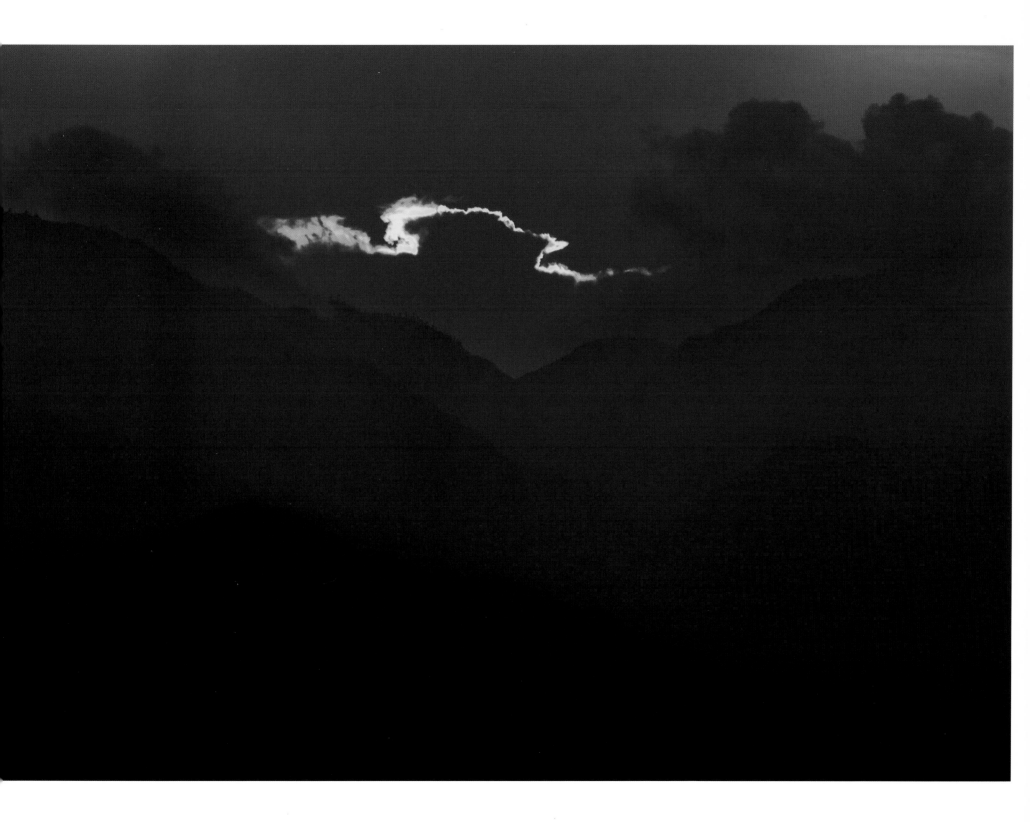

Anger, lust – these enemies of mine –

Are limbless and devoid of faculties.

They have no bravery, no cleverness.

How then have they made of me their slave?

Shantideva

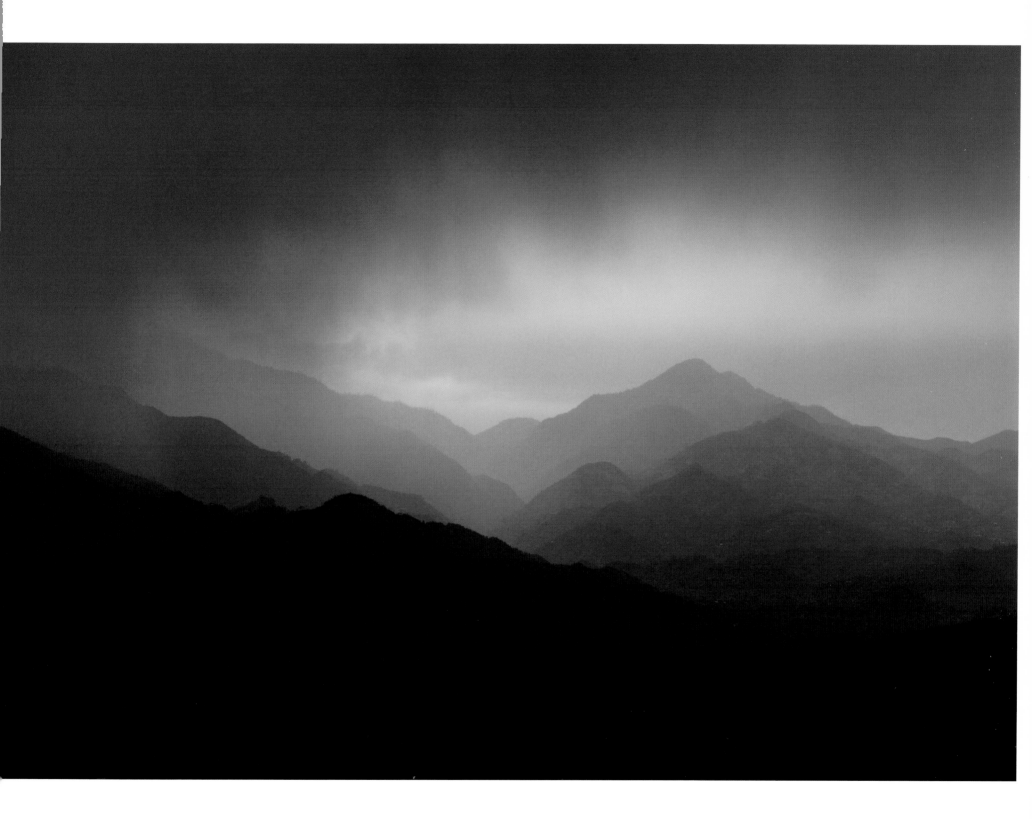

If there is a remedy when trouble strikes,

What reason is there for despondency?

And if there is no help for it,

What use is there in being sad?

Shantideva

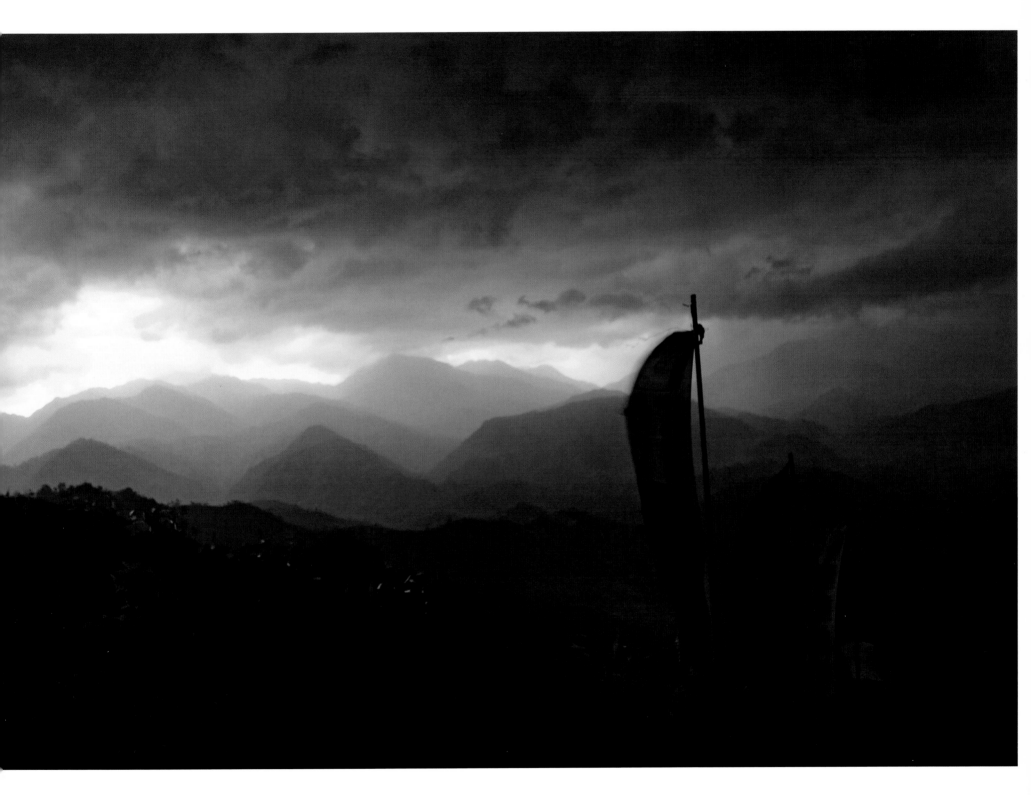

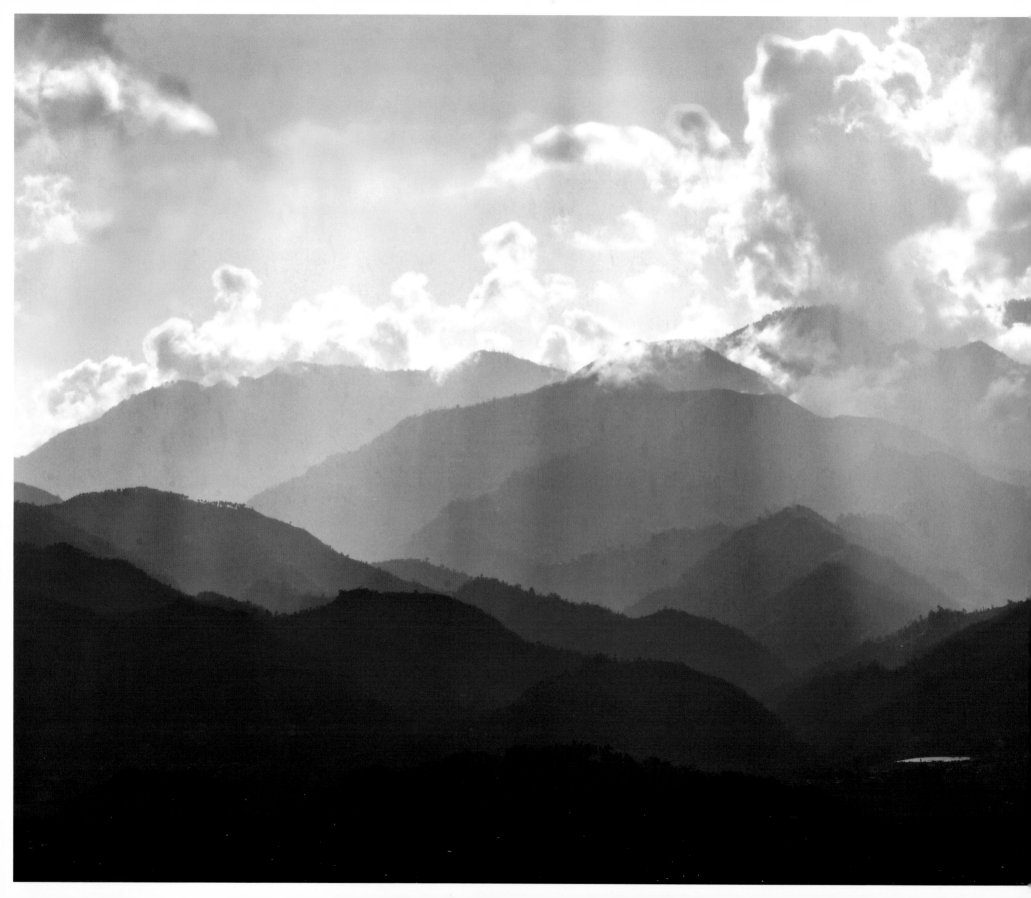

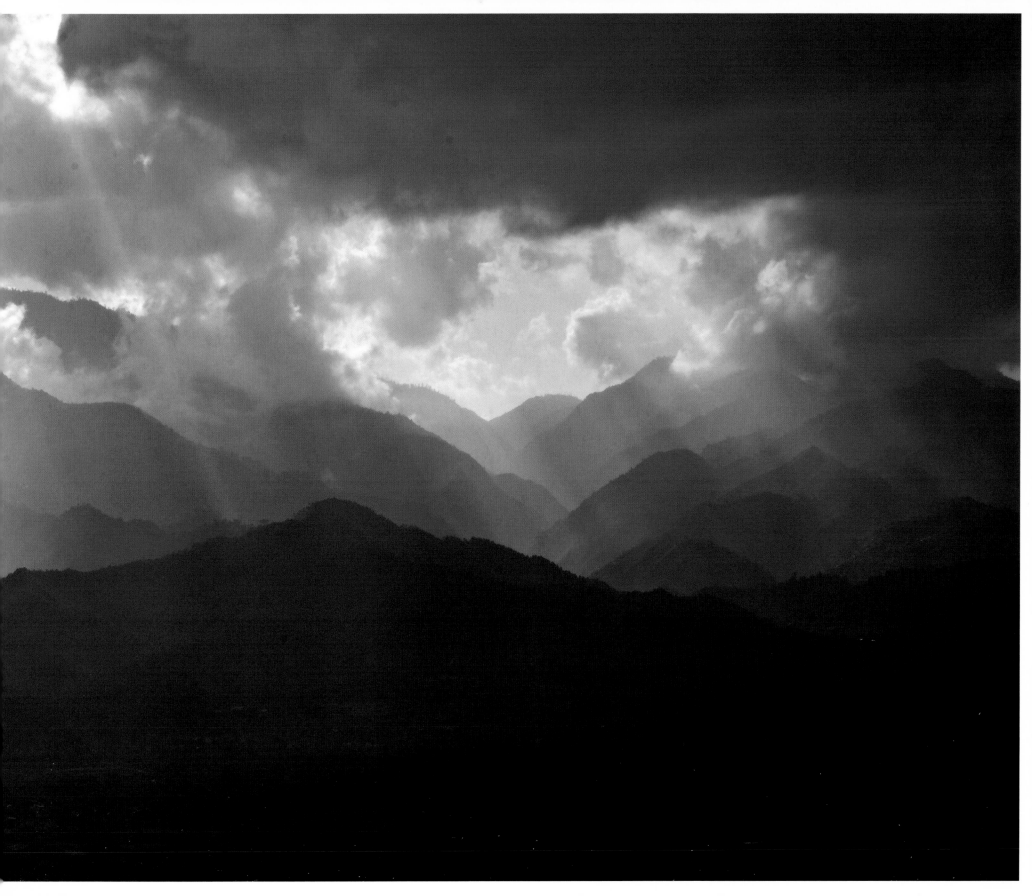

How marvellous human society would be if everyone added his own wood to the fire instead of crying over the ashes!

Alain

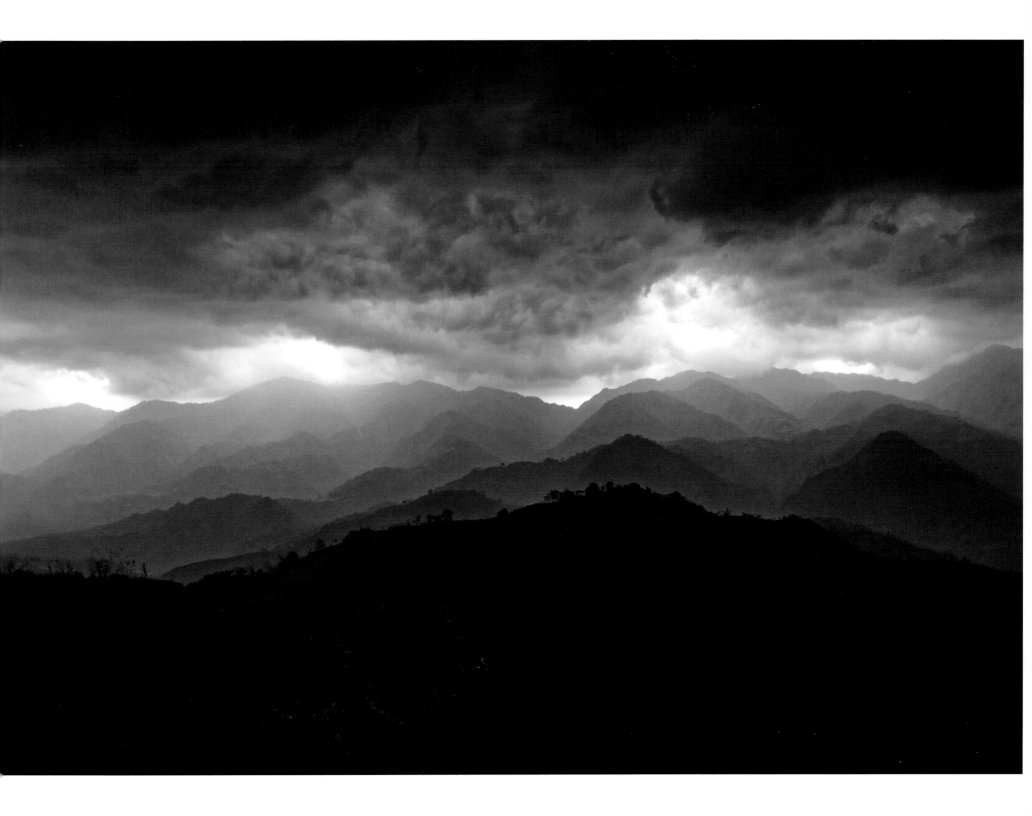

We read the world wrong and say that it deceives us.

Rabindranath Tagore

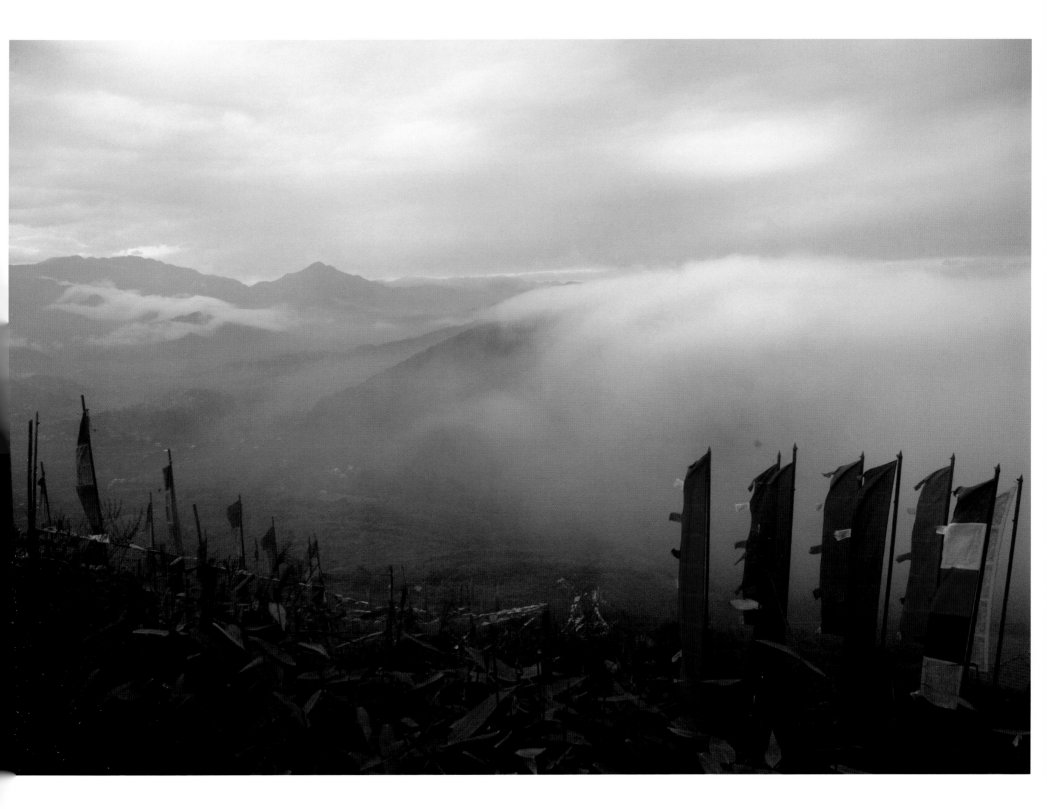

A single flash of anger shatters good works gathered in a thousand ages.

Shantideva

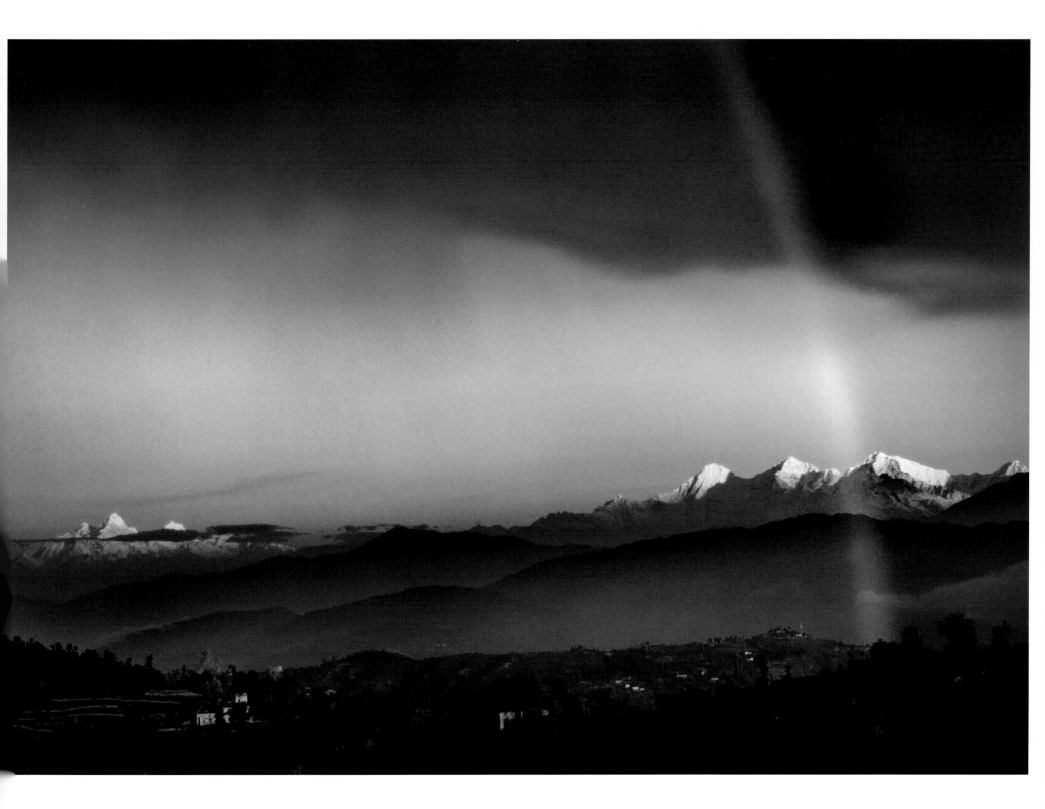

I turned my head, looking south,

And saw a pattern of rainbows.

I thought of all phenomena

At once both apparent and empty.

I then experienced a non-dual, natural clarity.

All nihilist and eternalist viewpoints

Completely abandoned.

Shabkar

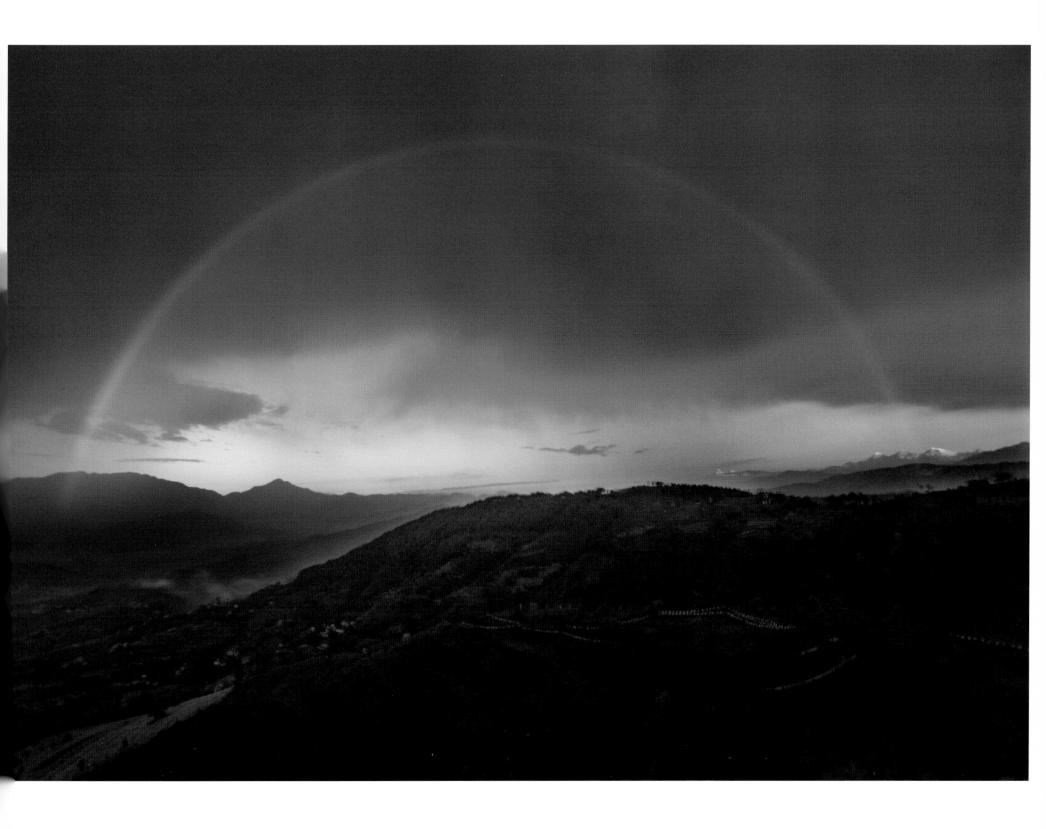

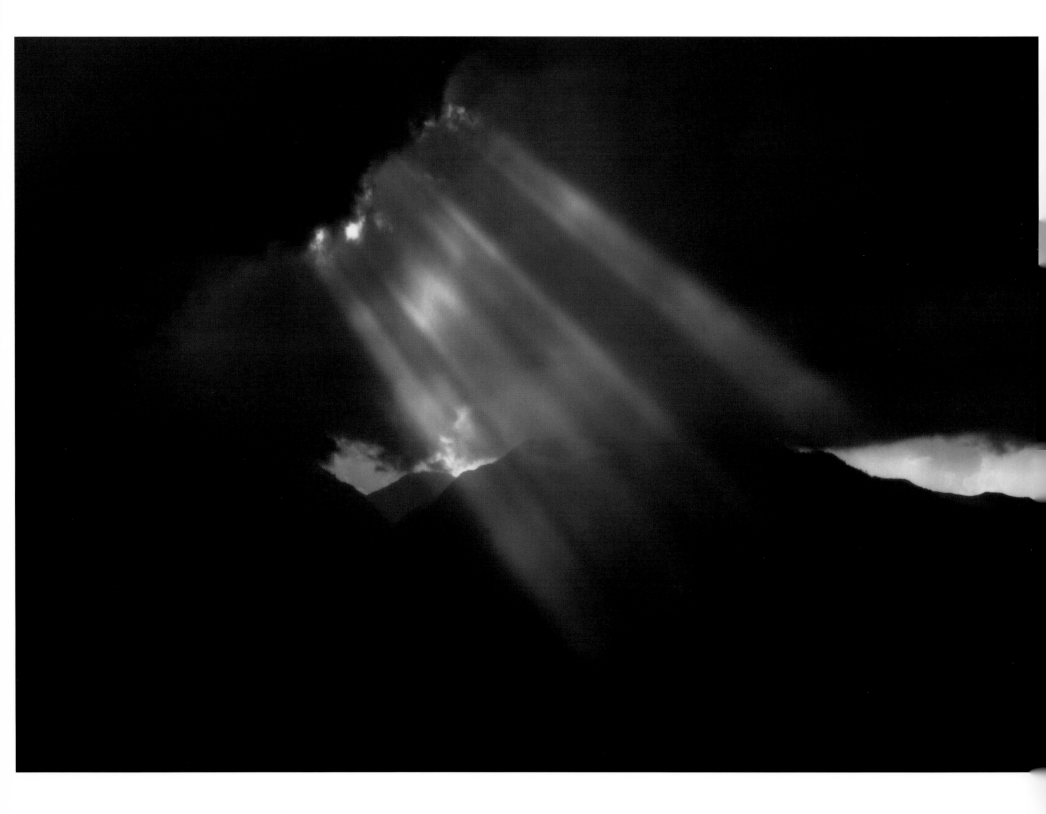

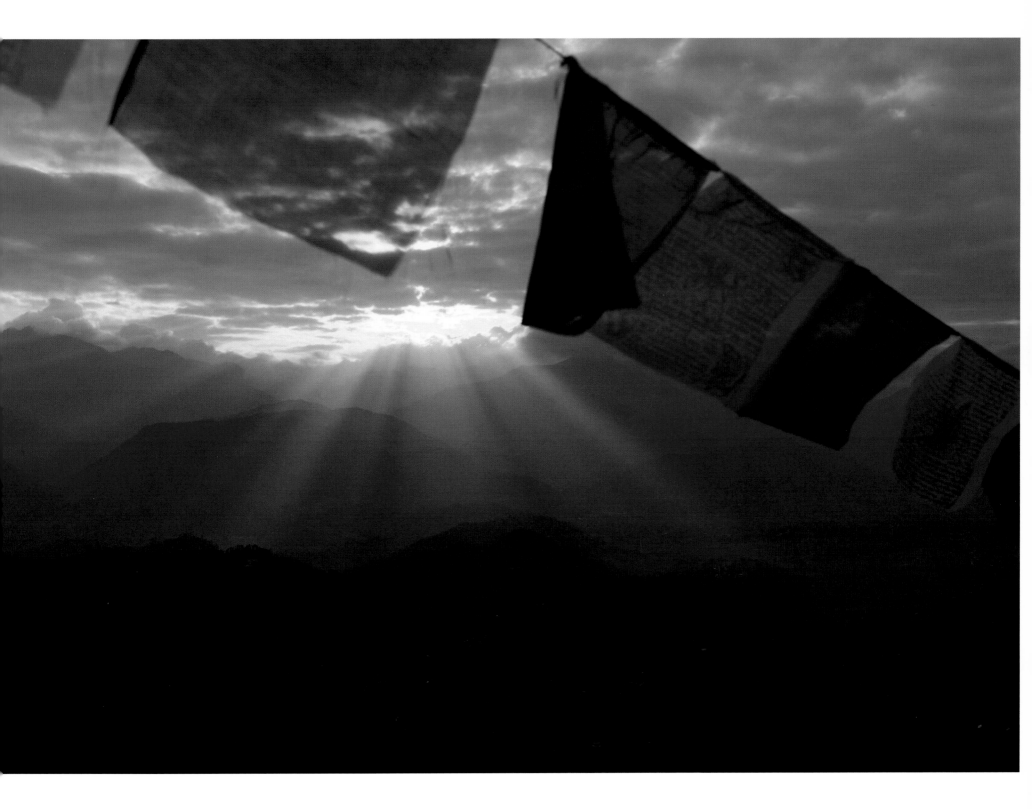

She loved the rain as much as the sun. Her least thoughts had the cheery colours of lovely, hearty flowers, pleasing to the eye.

Alain

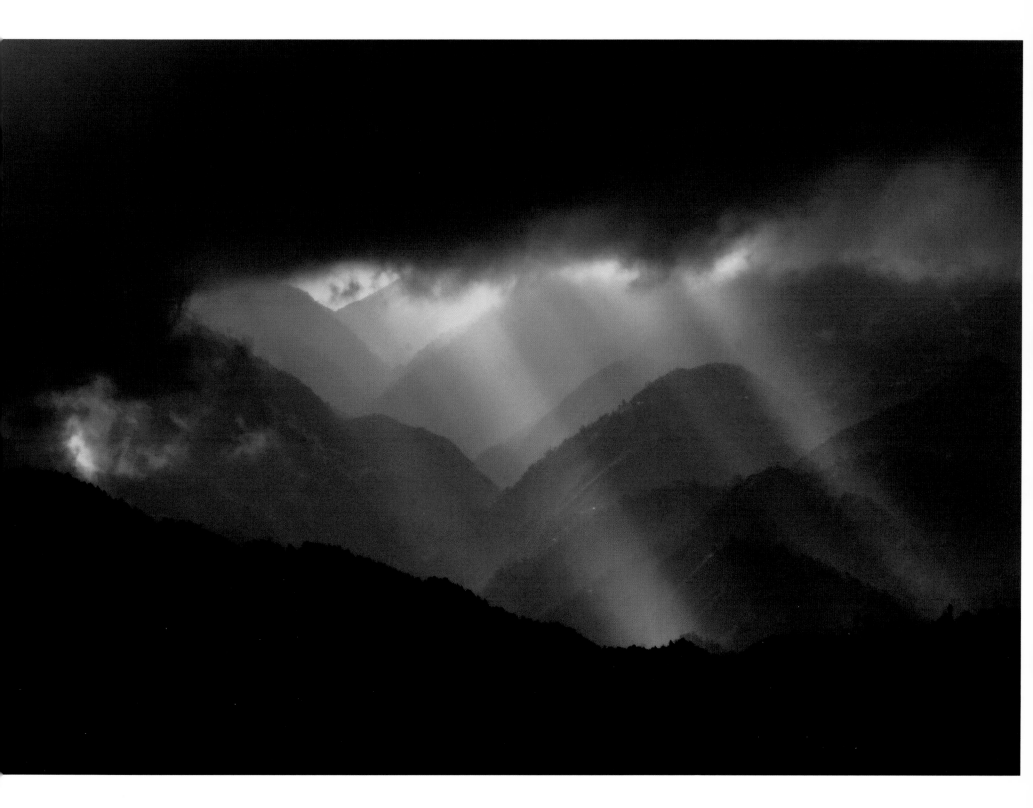

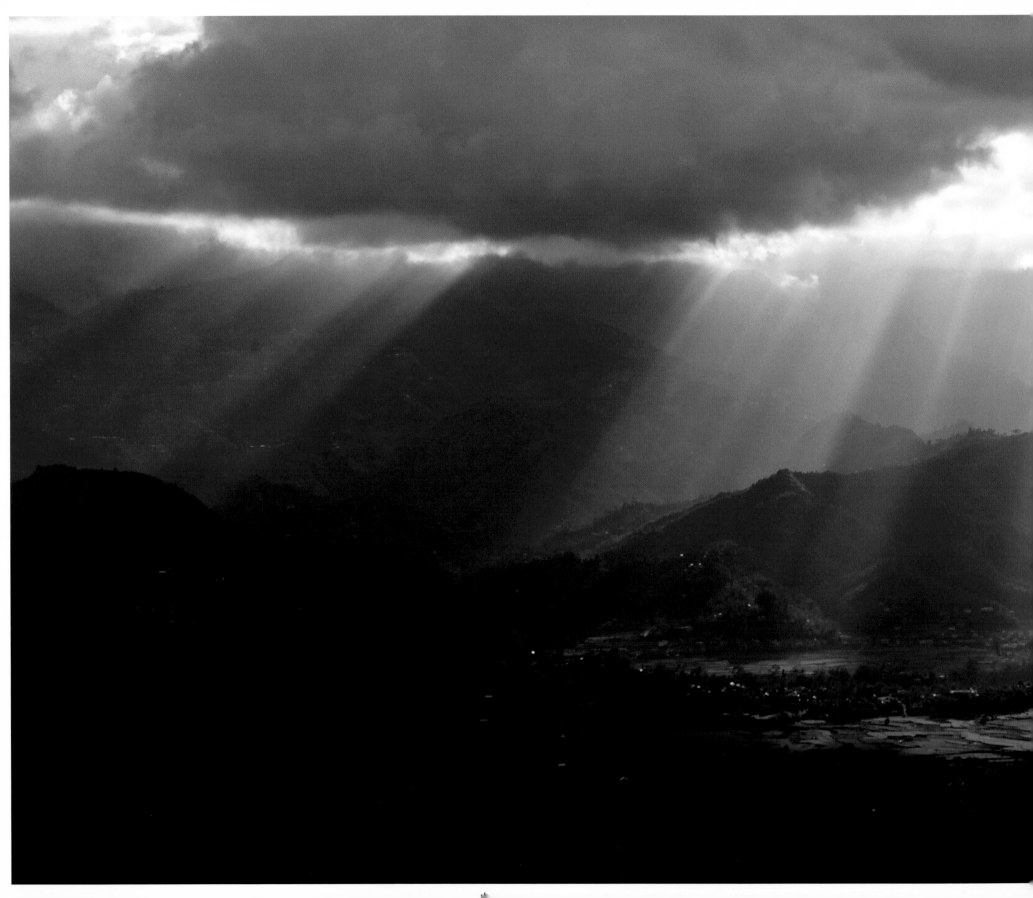

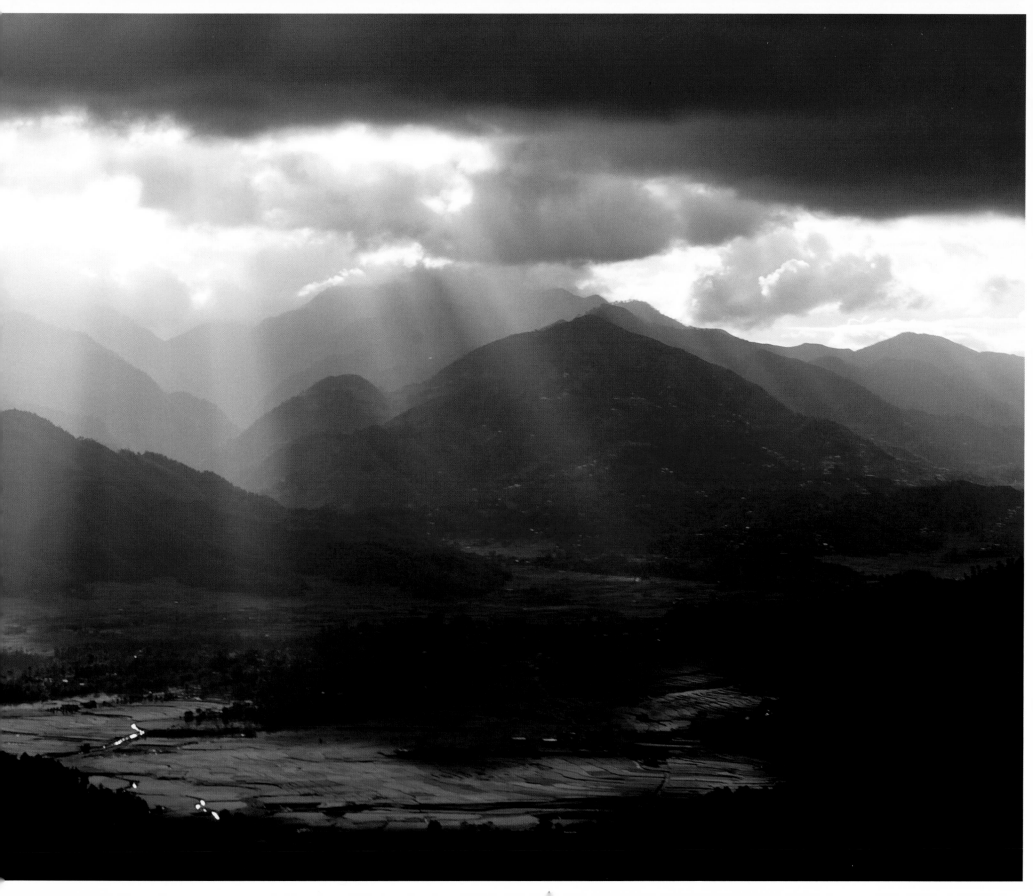

When one has a stone hut

And a natural abundance of slate, water and firewood

All the necessities are gathered.

At this mountain, happiness and spiritual fulfilment come together;

For those who meditate in such a place

The sun of meditation and realization will dawn.

Shabkar

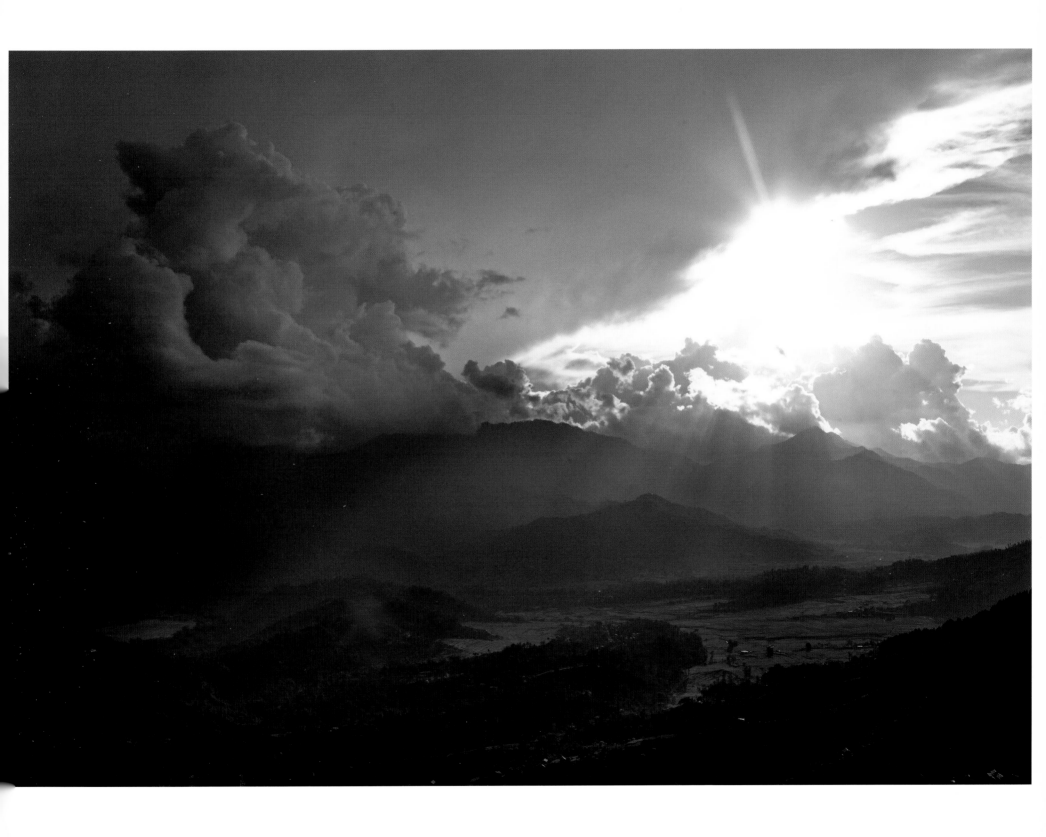

Seeking happiness outside ourselves is like waiting for sunshine in a cave facing north.

Tibetan saying

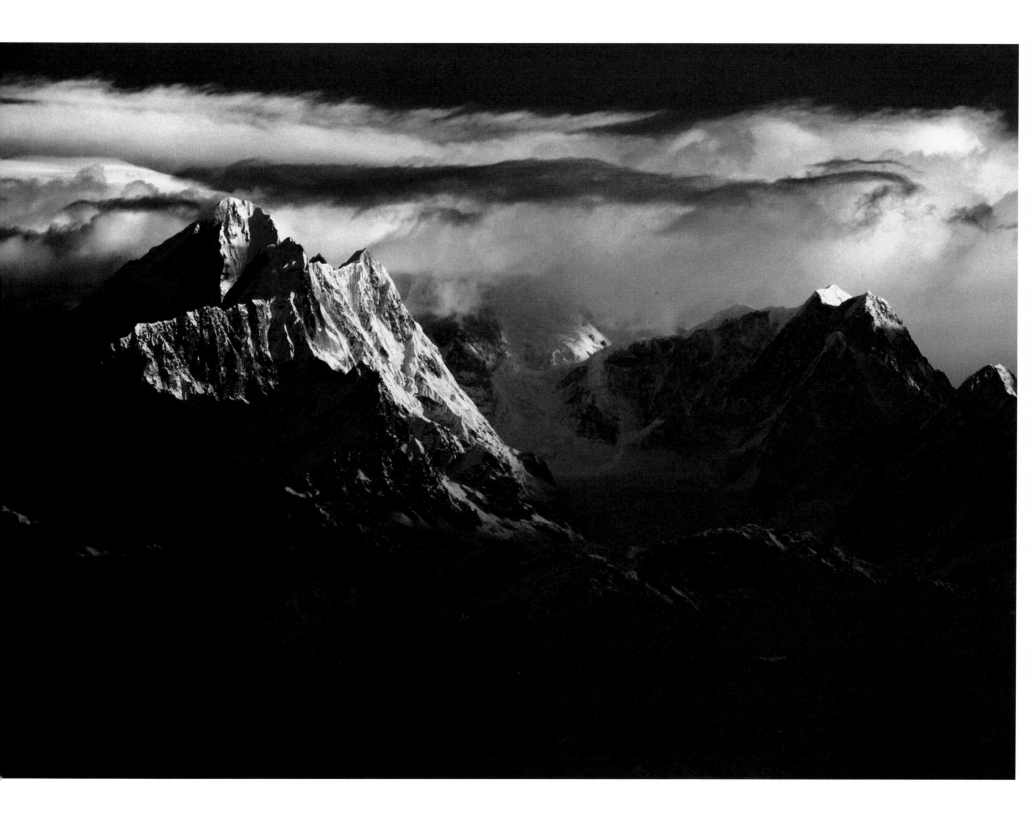

If you long for mountain solitudes

Under peaks wreathed in mist,

In steep, rocky cliffs there are natural caves;

To live in such places will bring you immediate and ultimate joy.

Kalden Gyatso

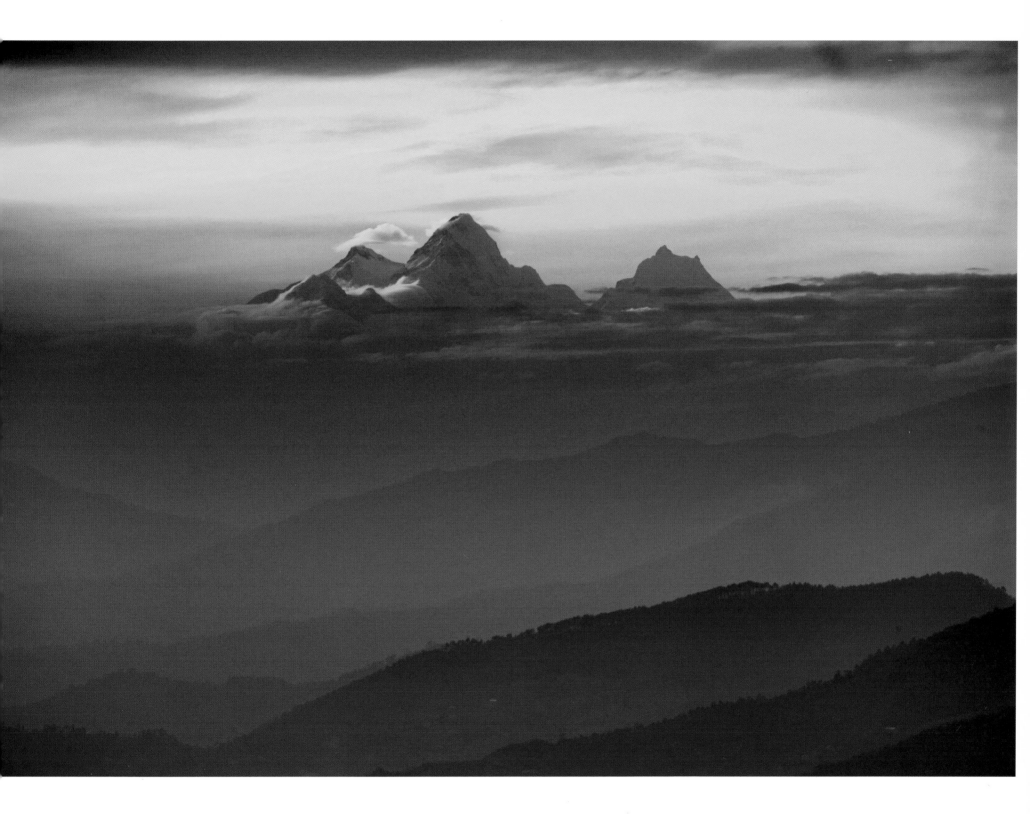

If you recognize the void nature of thoughts at the very moment they arise, they will dissolve.

Attachment and hatred will never be able to disturb the mind.

Deluded emotions will collapse by themselves.

No negative actions will be accumulated, so no suffering will follow.

Dilgo Khyentse Rinpoche

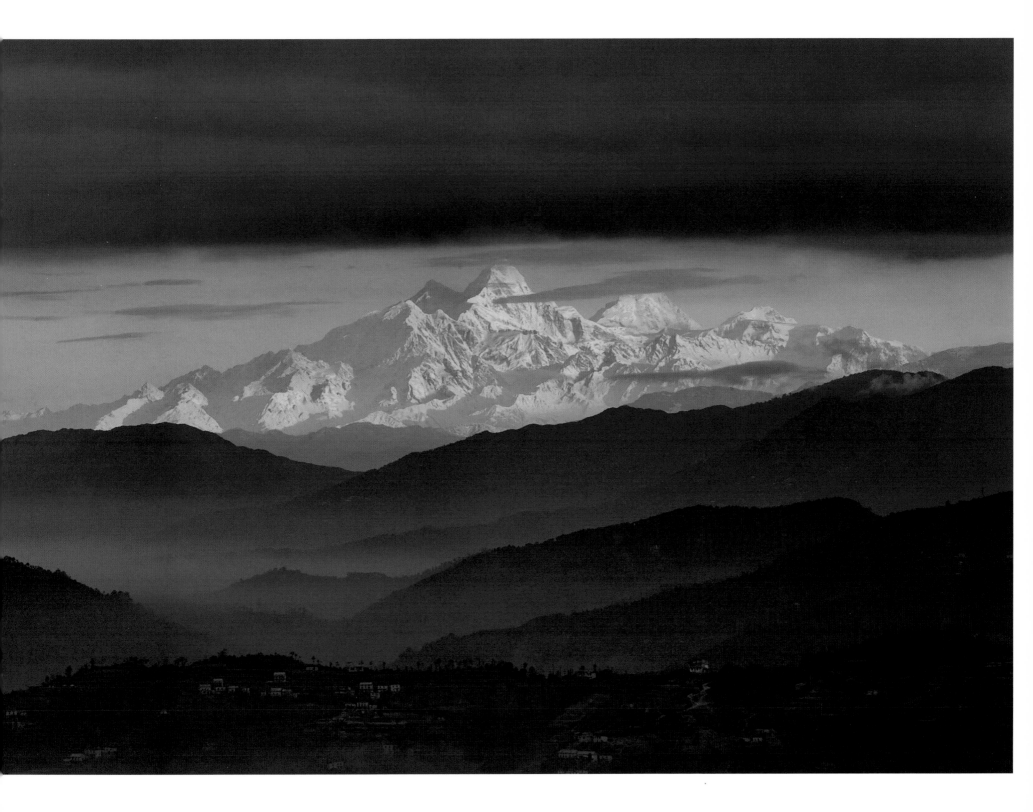

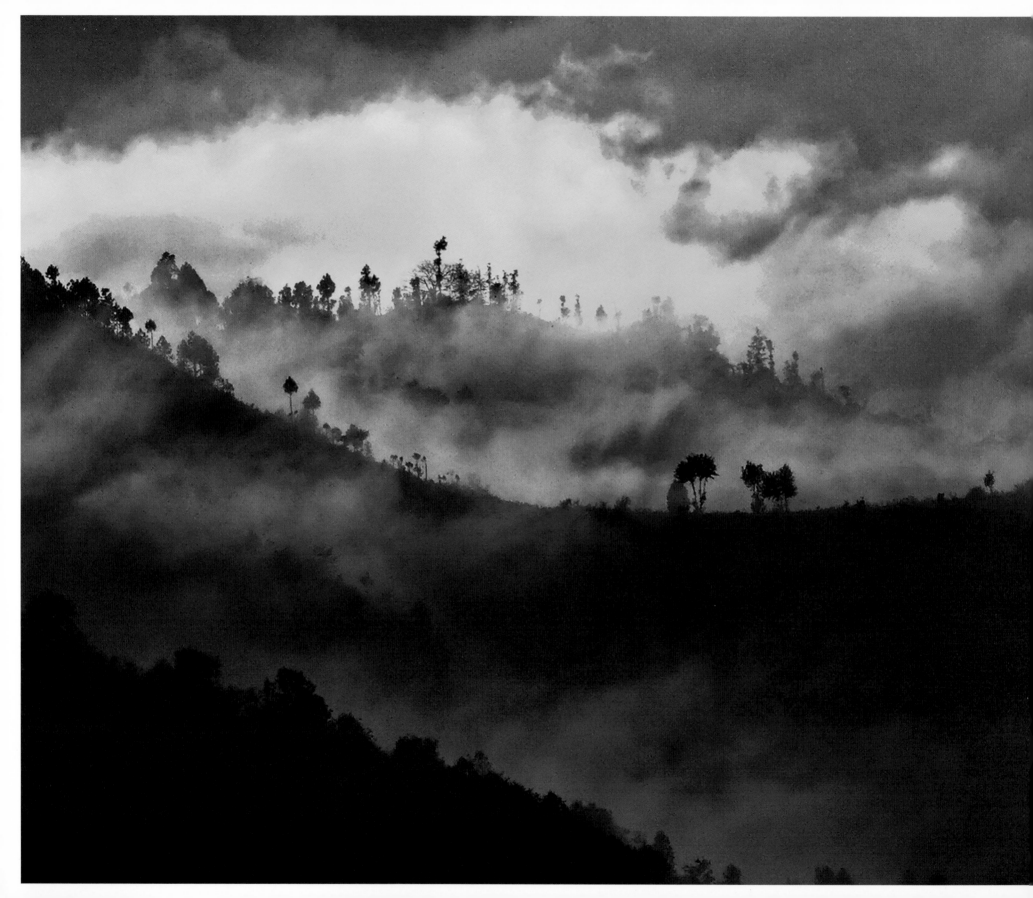

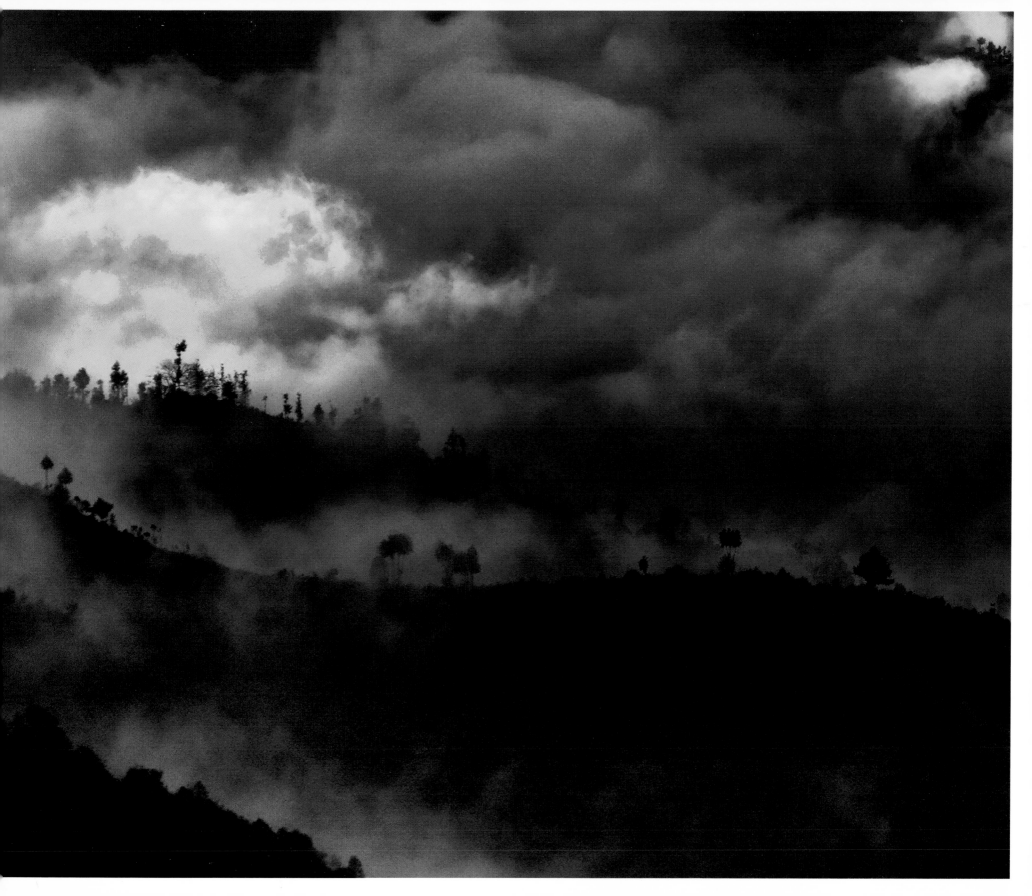

What is not given is lost.

Father Ceyrac

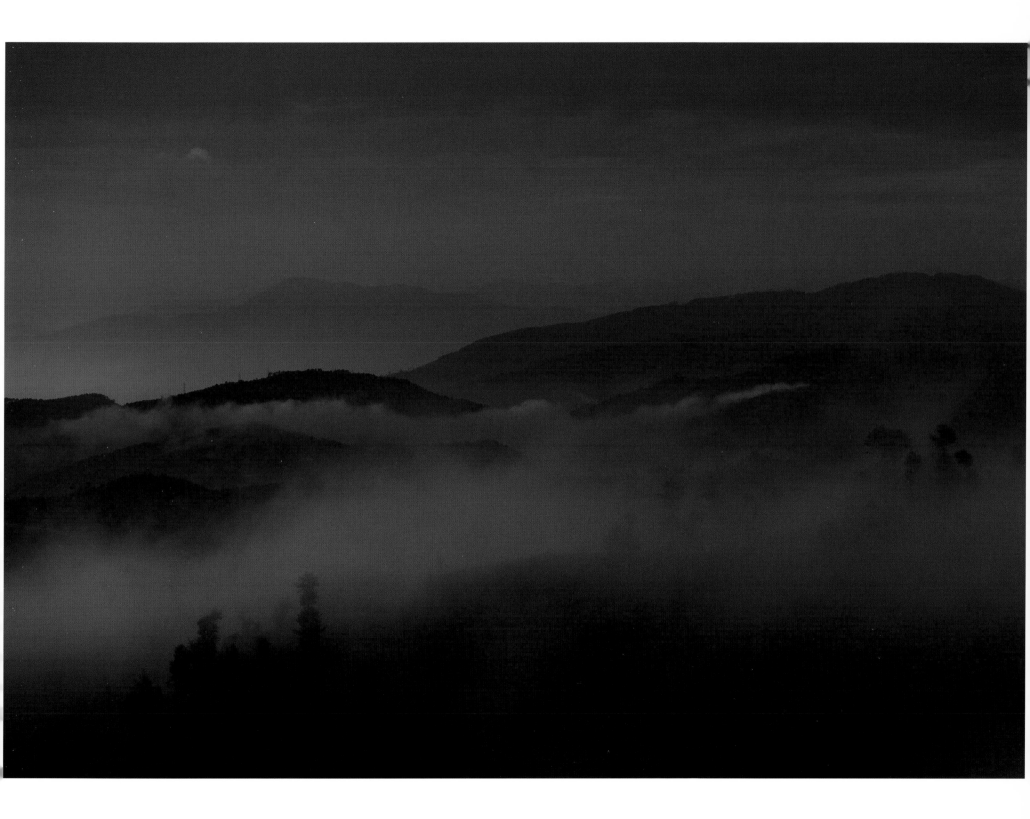

No task is so big that it cannot be broken down into smaller, easier tasks.

Buddhist saying

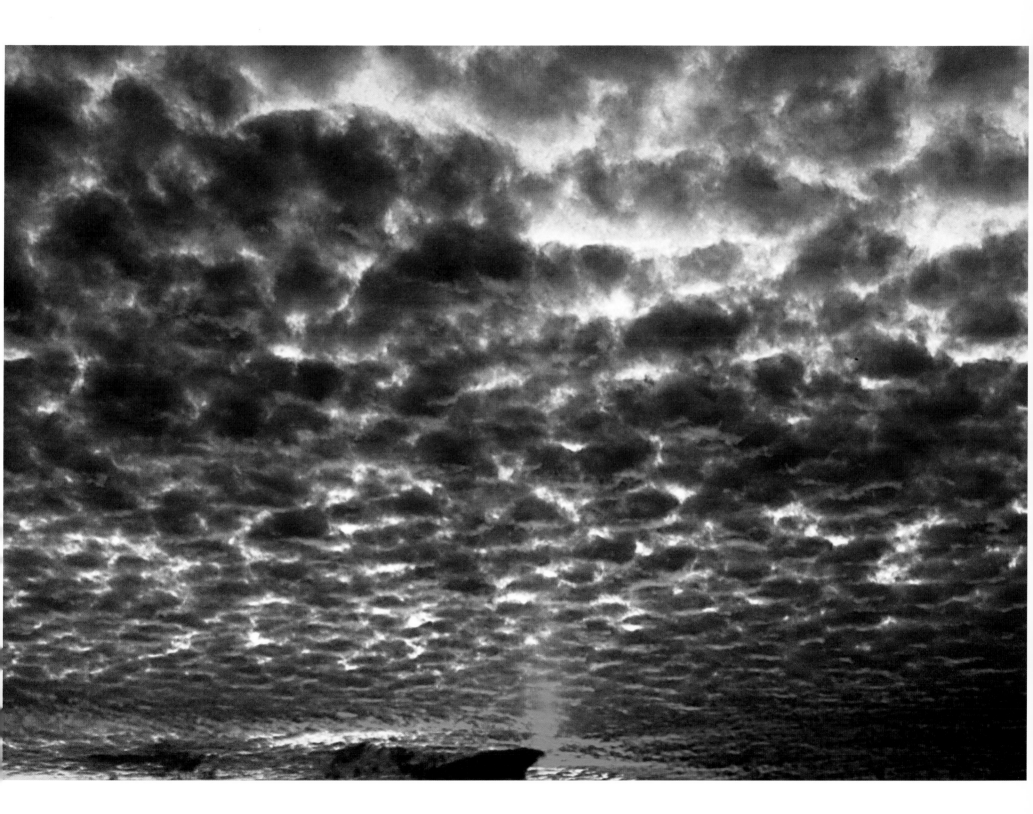

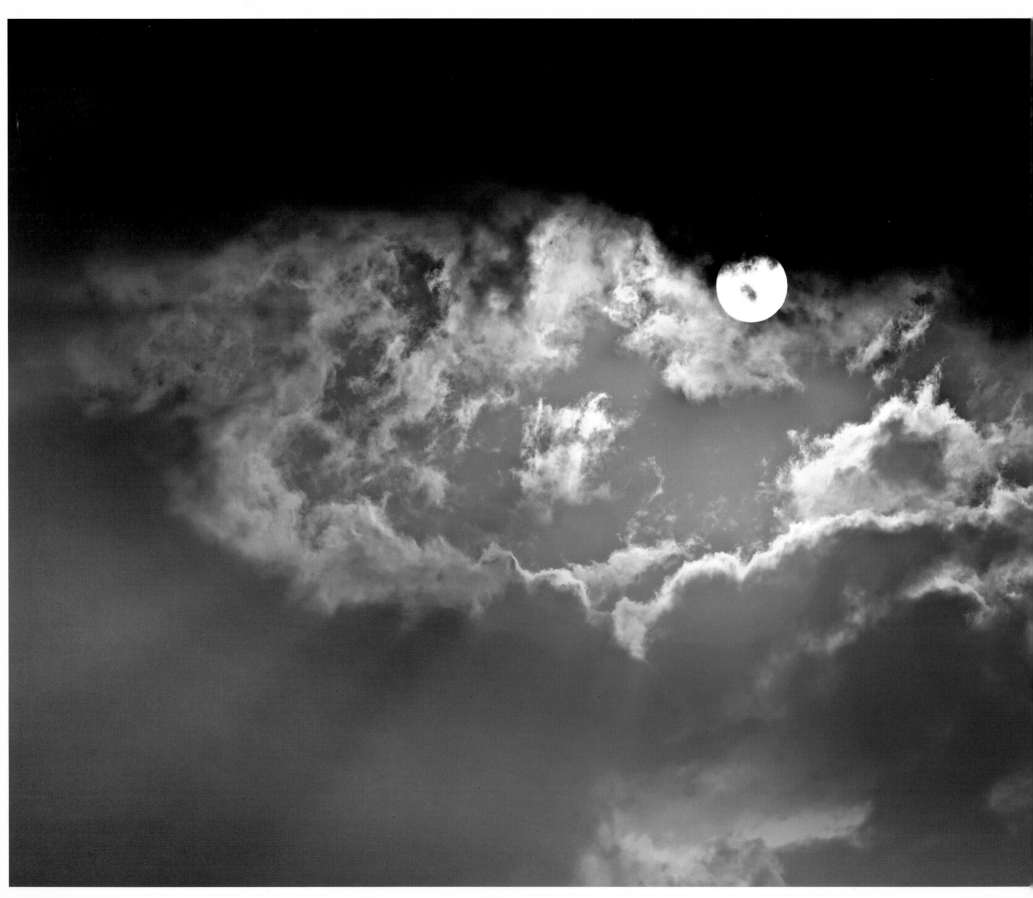

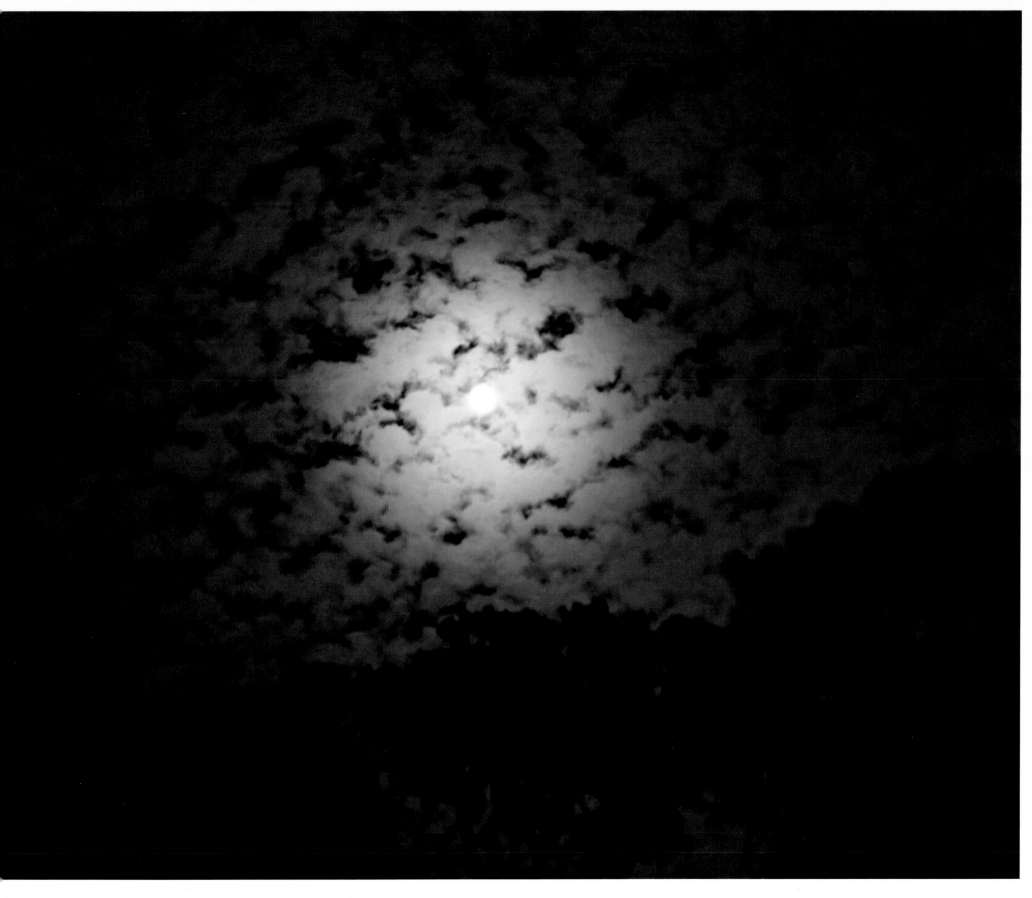

If you're afraid of your thoughts, you're giving them power over you, because they seem so solid and real, so true.

Yongey Mingyur Rinpoche

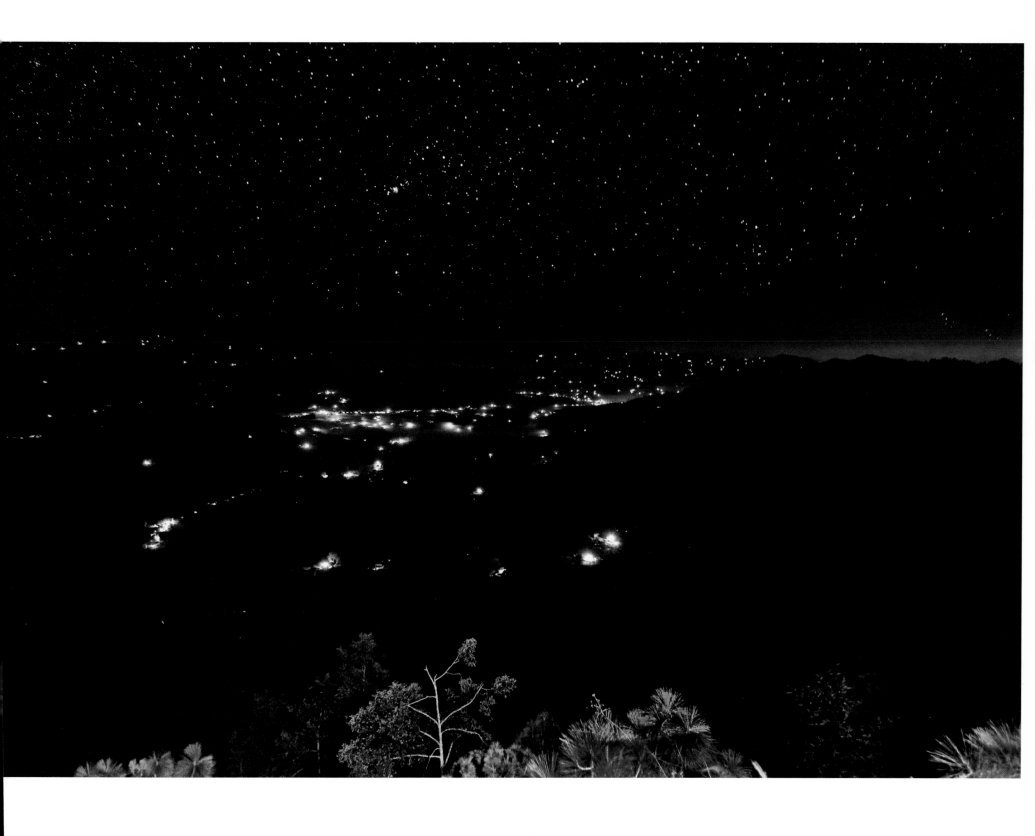

It's not the magnitude of the task that matters, it's the magnitude of our courage.

Matthieu Ricard

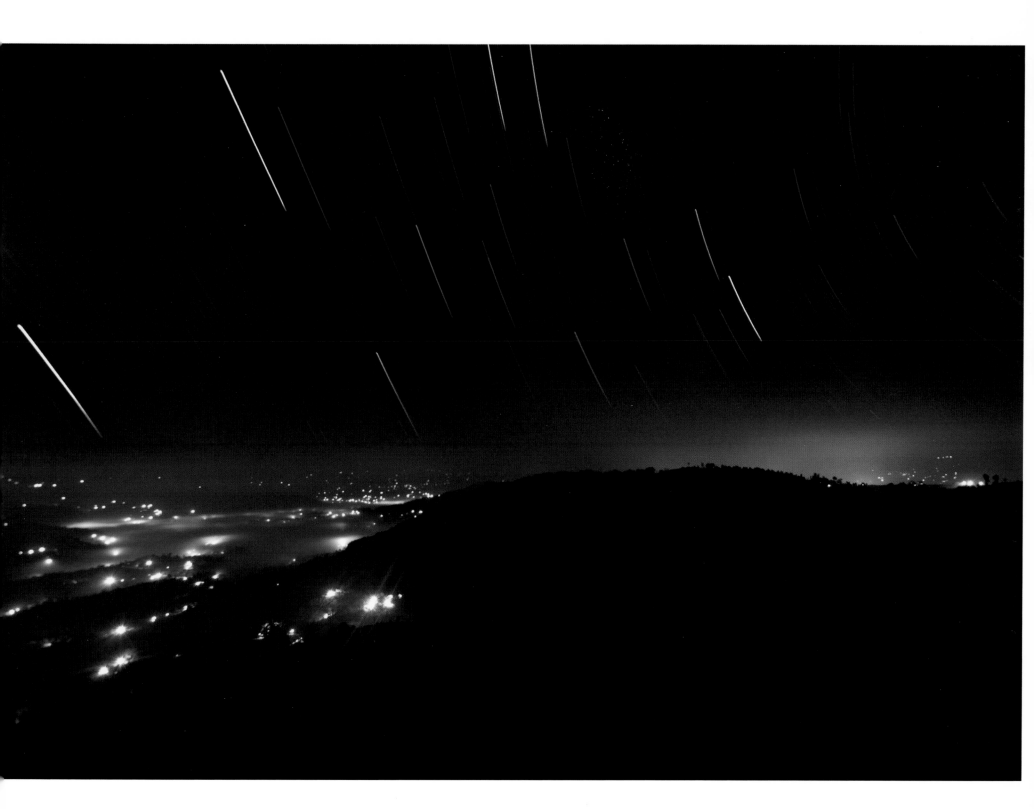

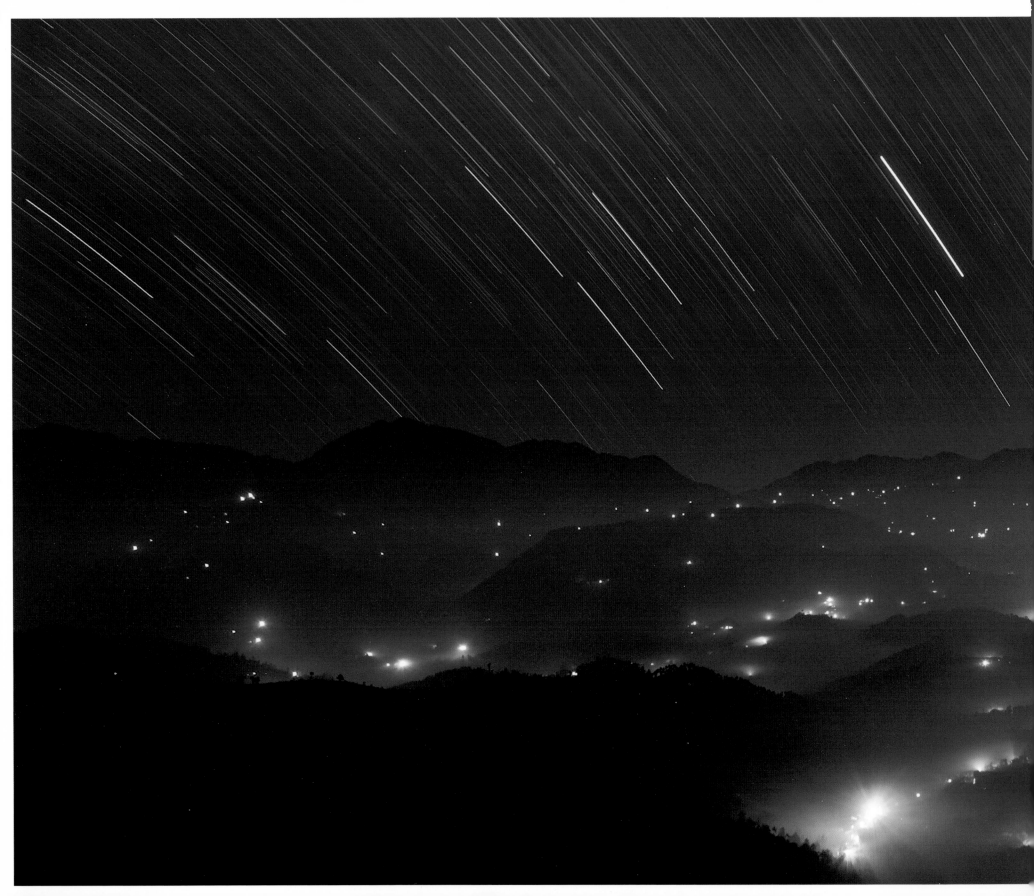

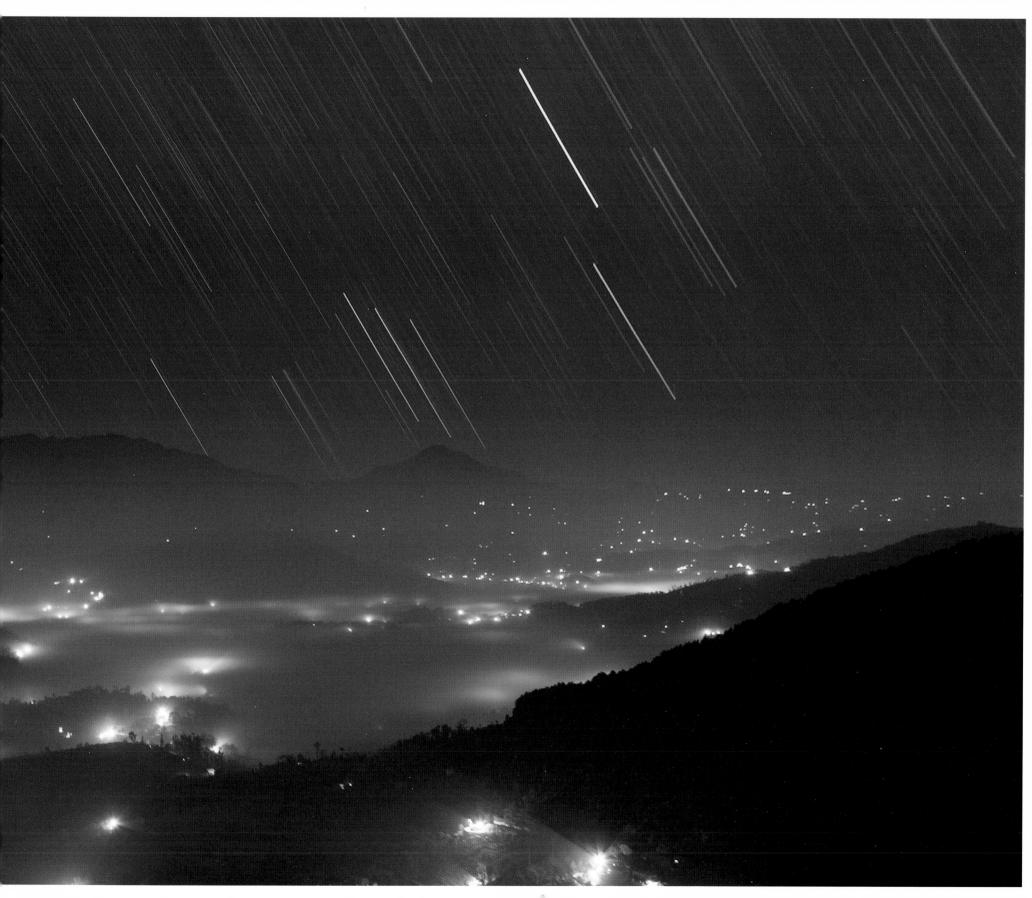

Remember that there are two kinds of lunatic: those who don't know that they must die, and those who have forgotten that they're alive.

Patrick Declerk

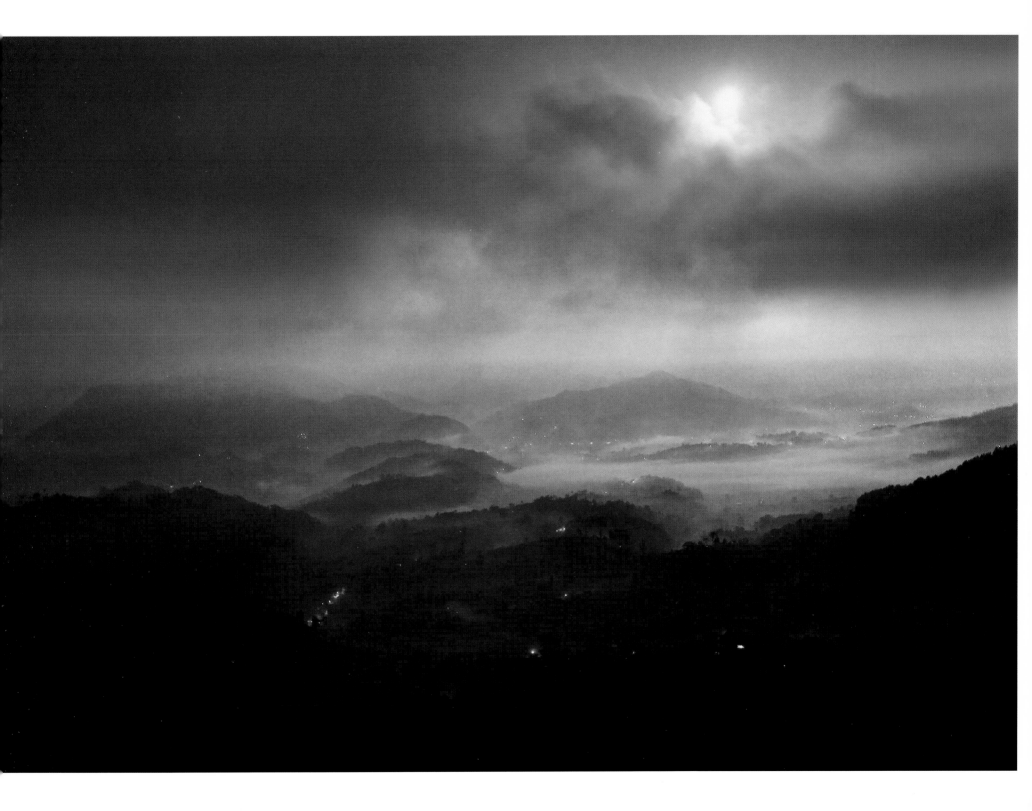

The happiest man is he who has no trace of malice in his soul.

Plato

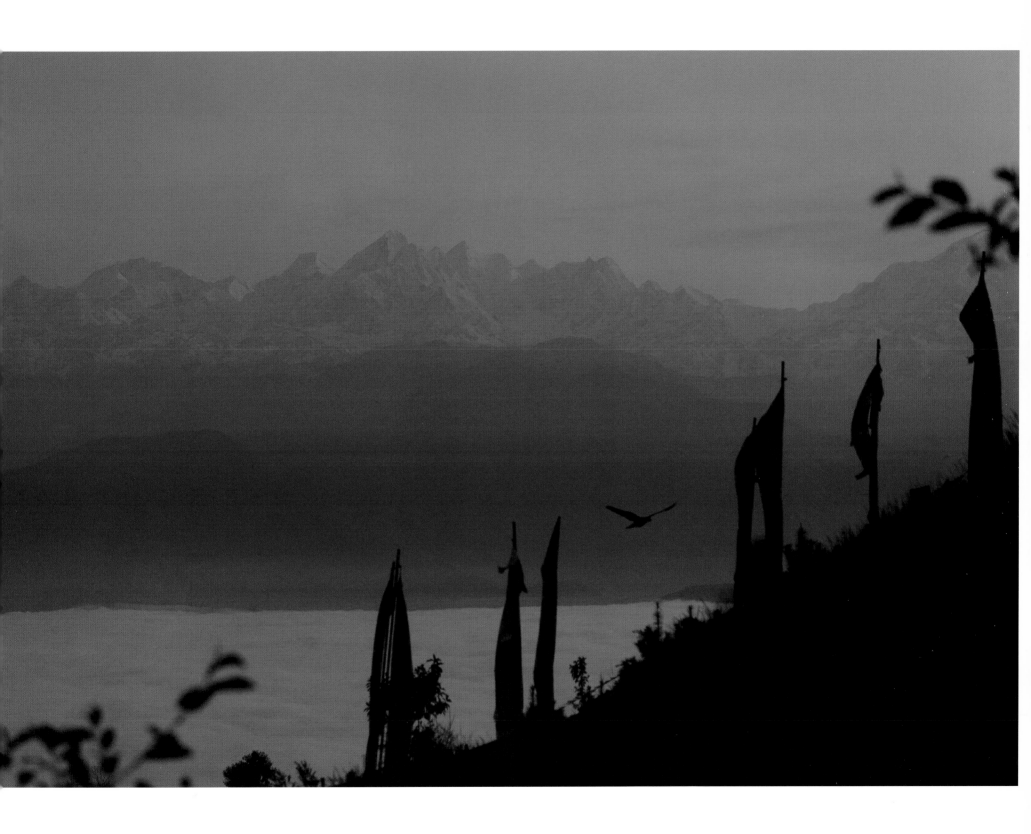

The hand and other limbs are many and distinct,

But all are one – one body to be kept and guarded.

Likewise, different beings in their joys and sorrows,

Are, like me, all one in wanting happiness.

Shantideva

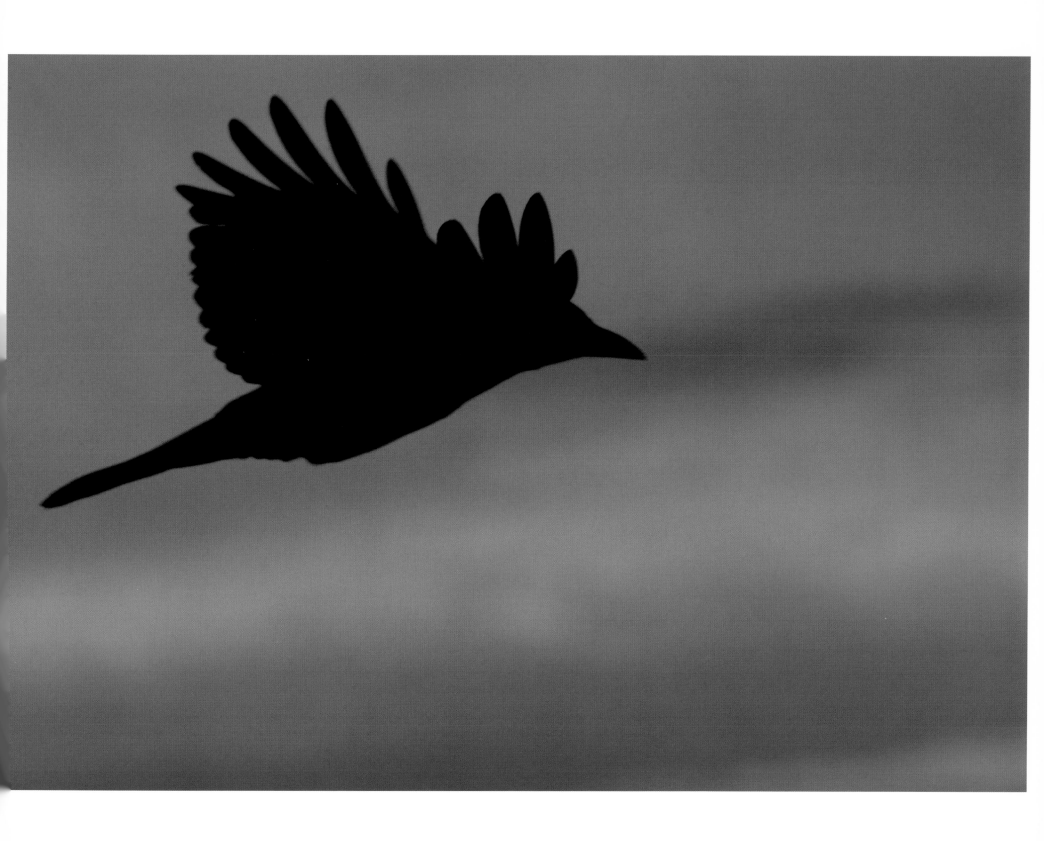

BIBLIOGRAPHY

Alain, *Alain on Happiness*, New York: Ungar, 1973

Patrick Declerk, 'Exhortations à moi-même' in 'La Sagesse d'aujourdhui', *Nouvel Observateur*, special issue no. 47, April–May 2002

Dilgo Khyentse Rinpoche, *One Hundred Verses of Advice of Padampa Sangye*, translated by Matthieu Ricard and John Canti of the Padmakara Translation Group, Boston (MA): Shambhala Publications, 2002

Dilgo Khyentse Rinpoche, *The Heart Treasure of the Enlightened Ones: The Practice of View, Meditation, and Action*, translated by Matthieu Ricard and John Canti of the Padmakara Translation Group, Boston (MA) & London: Shambhala Publications, 1992

Romain Rolland, *Jean-Christophe*, vol. VIII, Paris: Albin Michel, 1952

Shabkar Tsogdruk Rangdrol, *The Life of Shabkar: The Autobiography of a Tibetan Yogin*, with a foreword by the Dalai Lama, translated by Matthieu Ricard, Ithaca (NY): Snow Lion Publications, 2001

Shantideva, *The Way of the Bodhisattva: A Translation of the Bodhicharyavatara*, with a foreword by the Dalai Lama, translated by the Padmakara Translation Group, Boston (MA): Shambhala Publications, 2003

Philip Dormer Stanhope, 4th Earl of Chesterfield. Letter to his son.

Rabindranath Tagore, *Stray Birds*, LXXV, New York: The Macmillan Company, 1916

Henry David Thoreau, *Where I Lived & What I Lived For*, Waltham St Lawrence: Golden Cockerel Press, 1924

Yongey Mingyur Rinpoche with Eric Swanson, *The Joy Of Living*, New York: Harmony Books, 2007

ACKNOWLEDGMENTS

I would like to thank with all my heart Rabjam Rinpoche, the abbot of Shechen Monastery, and the monks at the Pema Ösel Ling Retreat. A big thank you also goes to my publisher Hervé de La Martinière, who was wholeheartedly behind this project, Emmanuelle Halkin, who was in charge of putting it together, Andrey Hette, who oversaw its design, and everyone else involved.

The author's share of the proceeds from this book has been entirely donated to various humanitarian projects in Tibet, Nepal, India and Bhutan. To find out more about this work, please contact:
Dilgo Khyentse Fellowship
109 Mowbray Drive
Kew Gardens
NY 11415
USA
shechen@sprynet.com
www.shechen.org
www.karuna-asia.org

The photographs in this book are available as signed limited-edition prints.
For more details, please go to www.shechen.org

Translated from the French *Un Voyage immobile: L'Himalaya vu d'un ermitage* by John Canti

First published in the United Kingdom in 2007 by Thames & Hudson Ltd,
181A High Holborn, London WC1V 7QX

www.thamesandhudson.com

First published in 2007 in hardcover in the United States of America by
Thames & Hudson Inc., 500 Fifth Avenue, New York, New York 10110

thamesandhudsonusa.com

Original version © 2007 Éditions de La Martinière, Paris
This edition © 2007 Thames & Hudson Ltd, London

British Library Cataloguing-in-Publication Data
A catalogue record for this book is available from the British Library

Library of Congress Catalog Card Number
2007903834

ISBN 978-0-500-54352-8

Printed in France